T0209675

An Analysis of

Abraham Maslow's

A Theory of Human Motivation

Stoyan Stoyanov

Published by Macat International Ltd
24:13 Coda Centre, 189 Munster Road, London SW6 6AW.

Distributed exclusively by Routledge
2 Park Square, Milton Park, Abingdon, Oxon OX14 4RN
711 Third Avenue, New York, NY 10017, USA

Routledge is an imprint of the Taylor & Francis Group, an informa business

www.macat.com
info@macat.com

Cataloguing in Publication Data
A catalogue record for this book is available from the British Library.
Library of Congress Cataloguing-in-Publication Data is available upon request.
Cover illustration: Etienne Gilfillan

ISBN 978-1-912303-63-2 (hardback)
ISBN 978-1-912127-80-1 (paperback)
ISBN 978-1-912282-51-7 (e-book)

Notice

CONTENTS

THE MACAT LIBRARY

The Macat Library is a series of unique academic explorations of seminal works in the humanities and social sciences – books and papers that have had a significant and widely recognised impact on their disciplines. It has been created to serve as much more than just a summary of what lies between the covers of a great book. It illuminates and explores the influences on, ideas of, and impact of that book. Our goal is to offer a learning resource that encourages critical thinking and fosters a better, deeper understanding of important ideas.

Each publication is divided into three Sections: Influences, Ideas, and Impact. Each Section has four Modules. These explore every important facet of the work, and the responses to it.

This Section-Module structure makes a Macat Library book easy to use, but it has another important feature. Because each Macat book is written to the same format, it is possible (and encouraged!) to cross-reference multiple Macat books along the same lines of inquiry or research. This allows the reader to open up interesting interdisciplinary pathways.

To further aid your reading, lists of glossary terms and people mentioned are included at the end of this book (these are indicated by an asterisk [*] throughout) – as well as a list of works cited.

Macat has worked with the University of Cambridge to identify the elements of critical thinking and understand the ways in which six different skills combine to enable effective thinking.
Three allow us to fully understand a problem; three more give us the tools to solve it. Together, these six skills make up the **PACIER** model of critical thinking. They are:

ANALYSIS – understanding how an argument is built
EVALUATION – exploring the strengths and weaknesses of an argument
INTERPRETATION – understanding issues of meaning

CREATIVE THINKING – coming up with new ideas and fresh connections
PROBLEM-SOLVING – producing strong solutions
REASONING – creating strong arguments

To find out more, visit **WWW.MACAT.COM.**

CRITICAL THINKING AND "A THEORY OF HUMAN MOTIVATION"

Primary critical thinking skill: CREATIVE THINKING
Secondary critical thinking skill: REASONING

US psychologist Abraham Maslow's *A Theory of Human Motivation* is a classic of psychological research that helped change the field for good. Like many field-changing thinkers, Maslow was not just a talented researcher, he was also a creative thinker – able to see things from a new perspective and show them in a different light. At a time when psychology was dominated by two major schools of thought, Maslow was able to forge a new, third paradigm, that remains influential today. Sigmund Freud's psychoanalysis had developed the idea of understanding the mind through dialogue between patient and analyst. The behaviorism of Ivan Pavlov and John Watson had focused on comprehending the mind through behaviors that could be measured, trained, and changed. Maslow, however, generated new ideas, forging what he called "positive" or "humanistic psychology". His argument was that humans are psychologically motivated by a series of hierarchical needs, starting with the most essential first. Maslow thought it important for the advancement of psychology to identify, group and rank these needs in terms of priority. His belief in the value of this third way was important in leading those who studied psychology to redefine the discipline, and so see it in new ways.

ABOUT THE AUTHOR OF THE ORIGINAL WORK

Psychologist **Abraham Maslow** was born in Brooklyn, New York, in 1908. The son of Russian Jewish immigrants, he experienced anti-Semitism during his youth. Despite this experience, Maslow embarked on a remarkable academic career, highlighting the importance of humanity's positive characteristics in his work. He was profoundly affected by the horrors of World War II, which inspired him to find a way to better understand the human mind. With *A Theory of Human Motivation* Maslow challenged the dominant ideas of his discipline to establish humanistic psychology—the idea that human beings are fundamentally good. He died in 1970 at the age of 62.

ABOUT THE AUTHOR OF THE ANALYSIS

Dr Stoyan Stoyanov holds a PhD in management from the University of Edinburgh. He is currently a lecturer at the Hunter Centre for Entrepreneurship at the University of Strathclyde, Glasgow.

ABOUT MACAT

GREAT WORKS FOR CRITICAL THINKING

Macat is focused on making the ideas of the world's great thinkers accessible and comprehensible to everybody, everywhere, in ways that promote the development of enhanced critical thinking skills.

It works with leading academics from the world's top universities to produce new analyses that focus on the ideas and the impact of the most influential works ever written across a wide variety of academic disciplines. Each of the works that sit at the heart of its growing library is an enduring example of great thinking. But by setting them in context – and looking at the influences that shaped their authors, as well as the responses they provoked – Macat encourages readers to look at these classics and game-changers with fresh eyes. Readers learn to think, engage and challenge their ideas, rather than simply accepting them.

"Macat offers an amazing first-of-its-kind tool for
interdisciplinary learning and research. Its focus on works
that transformed their disciplines and its rigorous approach,
drawing on the world's leading experts and educational institutions,
opens up a world-class education to anyone."

Andreas Schleicher
Director for Education and Skills, Organisation for Economic
Co-operation and Development

'Macat is taking on some of the major challenges in university
education … They have drawn together a strong team of active
academics who are producing teaching materials that are
novel in the breadth of their approach.'

Prof Lord Broers,
former Vice-Chancellor of the University of Cambridge

'The Macat vision is exceptionally exciting. It focuses
upon new modes of learning which analyse and explain seminal texts
which have profoundly influenced world thinking and so social and
economic development. It promotes the kind of critical thinking
which is essential for any society and economy.
This is the learning of the future.'

Rt Hon Charles Clarke, former UK Secretary of State for Education

'The Macat analyses provide immediate access to the critical
conversation surrounding the books that have shaped their
respective discipline, which will make them an invaluable resource
to all of those, students and teachers, working in the field.'

Professor William Tronzo, University of California at San Diego

WAYS IN TO THE TEXT

KEY POINTS

- The American psychologist* Abraham H. Maslow (1908–70) was a strong believer in human virtues such as empathy and compassion, and his work highlighted the significance of concentrating on people's positive characteristics.

- Constructing his "hierarchy of needs,"* Maslow set out to show that humans are fundamentally motivated to satisfy a series of needs, starting with the most essential physiological* needs (those that are fundamental for the normal functioning of life) and needs of safety.

- Maslow is considered to be the founder of humanism,* regarded as the third most significant stream of psychological* research in the early twentieth century after psychoanalysis* (a theoretical and therapeutic approach to understanding and treating the unconscious mind) and behaviorism* (the theory that behaviors can be measured, trained, and changed, and that psychological disorders can be treated by addressing behavior).

Who Was Abraham H. Maslow?

Abraham Harold Maslow, the author of the paper "A Theory of Human Motivation" (1943) that introduced his theory of the

"hierarchy of needs," was born into a working-class family of Jewish immigrants in Brooklyn, New York, in 1908. Despite a childhood afflicted with the trauma of anti-Semitism[*1], he embarked on a remarkable academic career in which he highlighted the importance of humanity's positive characteristics.

Maslow was driven to academic excellence by his father and initially studied law, before taking an interest in psychology—the science that explores the human mind and behavior. He eventually completed his schooling in the psychology department of the University of Wisconsin, where he earned his doctorate in 1934. After returning to New York, he taught at Brooklyn College and Columbia University, where he worked closely with the psychologist Edward L. Thorndike* in the field of human sexuality.[2]

Maslow's insight into his subject was shaped by his cooperation with a number of renowned psychologists, including Alfred Adler,* Karen Horney,* and Erich Fromm.* However, his psychological ideas were influenced most by his family and the time in which he lived. Maslow was in his early 30s when World War II* broke out in Europe and, although he was not conscripted due to his age and university position, the war had a profound impact on his research.[3] Indeed, the conflict motivated him to understand the human mind through the prism of the new academic discipline of humanistic psychology,* and to develop a series of psychological works on his concept of self-actualization*—the drive to realize our full potential, unleash creativity, pursue knowledge, and give back to society.

Maslow was a firm believer in human virtues such as empathy, compassion, and kindness. Through his academic work, he focused on the positive qualities that people possess and the conditions that enable these qualities to emerge. The importance of the author and his work has been commemorated by a survey conducted by the American journal *Review of General Psychology*, which determined it to be the 10th most cited psychologist in the past century.[4] He died in California in 1970.

What Does "A Theory of Human Motivation" Say?

Maslow published the essay in July 1943, while working as a lecturer at Brooklyn College. It proposes that our actions are not automatic, unconscious responses to externally imposed forces such as demands or rules; rather, they are driven by "intrinsic goals" such as our aspirations towards self-development and by social values such as selflessness.[5]

Maslow seeks to explain human behavior through the concept of human potential* (for him, the belief that humans are inherently good, with largely untapped abilities and capacities) and through an individual's perpetual struggle to attain excellence.[6] He proposed that all mentally healthy people share the same motivations, with self-actualization being the most virtuous and socially constructive.[7]

To explain the forces that shape human behavior, Maslow proposed a psychological theory that humans are motivated by a series of needs, starting with the most essential. To demonstrate this, he constructed a linear hierarchy of needs beginning with physiological needs and proceeding to those of safety, love, and self-esteem, ending with those of self-actualization.

The most important of these needs are physiological—that is, those necessary for the healthy functioning of a person; when all else is stripped away, a human still needs oxygen, water, and food in order to survive. If any one of these elements is lacking, a person will eventually die. The next most important needs relate to safety: finding shelter and protection, for example. Maslow argues that this need is the primary reason why humans organize themselves into societies, because people recognize that they are safer in numbers than by themselves. He classes physiological and safety needs as essential needs, because it is difficult for people to survive without addressing these first.

Once these essential needs have been satisfied, even to a limited degree, other needs start to emerge as important. The third need relates to love and affection, and the sense of belonging to a group. The next relates to self-esteem: the need to be accepted and desired by

11

others. The final need is self-actualization, a term first coined by the German psychiatrist Kurt Goldstein,* who used it to describe people's drive to realize their full potential. While needs for love and self-esteem are commonly met in parts of the world where the essential needs are taken for granted, self-actualization is rare and often reveals itself in creativity, such as a painter, musician, or writer producing a work of merit.

Maslow recognized that while our needs are diverse, it was important for the advancement of the field of psychology to identify, group, and rank them in terms of priority. Each of the basic needs he identified is characterized by a common attribute and by a degree of urgency; this is why physiological needs are the most important, and those of self-actualization the least. In 1960, the psychologist Douglas McGregor* famously organized these needs into the pyramid graph widely recognized today.[8]

It is important, however, to know that satisfying these needs is not exclusive. It is not as if the moment one need is satisfied then you can go on to the next. For example, a person who is hungry or thirsty is still capable of love and affection, but when their physiological needs are threatened (when they are dying of thirst or hunger), their need for survival will override any other need. Who cares about love or affection when you *must* drink water or die? In other words, people satisfy parts of each basic need simultaneously, which explains why a poor person can struggle to satisfy their physiological needs, but still be capable of falling in love.

Why Does "A Theory of Human Motivation" Matter?

Maslow's foundational work is significant because it established humanistic psychology as a "third force" in the field of psychology. The three major forces of psychology are:

- Behaviorism: a field initiated by the Russian psychologist Ivan Pavlov and developed by the US psychologist John Watson,*

according to which behaviors can be measured, trained, and changed.

• Psychoanalysis: a method of treating psychopathology*—that is, the manifestation of behaviors that may be indicative of mental illness—by means of dialogue between a patient and a psychoanalyst (therapist). This field was pioneered by the Austrian neurologist and thinker Sigmund Freud.*

• Humanistic psychology: a field emphasizing the drive towards self-actualization and a belief in the inherently good nature of human beings.

As a young scholar writing during World War II, Maslow struggled to find a theory that fully explained the peculiarities of the time and their effects on human behavior. To him, psychoanalysis and behaviorism did not adequately explain people's unconscious drivers and perceptions. The limitations of these schools of thought were derived from their subjective methodology and questionable findings. The psychoanalytic view focused on examining unconscious conflicts and desires, and was formulated using mentally ill patients. Similarly, behaviorism analyzed the role of learning, but was flawed (in Maslow's view) because its conclusions were based on studies conducted on animals, not humans.

Maslow believed that to base studies on mentally healthy, human subjects would prove a much more logical approach. After all, only a small minority of the population are mentally ill, so the development of theories based on a healthy sample would be more applicable to a wider population. Because of this innovative approach to psychology, Maslow is today considered the founder of the third most significant stream of psychological research of the early twentieth century: humanism. ("Humanism" here refers to an approach to psychology emphasizing the value of human beings, individually and collectively, by turning from previously established psychological doctrines to

sound, measurable evidence.)

Aside from establishing humanistic psychology as the third force, Maslow's hierarchy of needs also offered researchers and clinical practitioners a new psychological construct that has been used as a stepping-stone for further explanation of human behavior and characteristics. Its importance is demonstrated by its ongoing inclusion in studies beyond the field of psychology, such as management, marketing, and strategy. The wide, interdisciplinary acceptance of the work is an indication of its enormous impact on contemporary academia. "A Theory of Human Motivation" has been cited in more than 14,000 academic works, while Maslow's subsequent publications, which built upon his theory, have been referenced over 24,000 times.[9] For a first publication this was a hugely important study, as it expanded the boundaries of contemporary psychological studies and challenged psychologists to revise their views on what appeared to be antiquated modes of analysis.

NOTES

1 Edward Hoffman, *The Right to be Human: A Biography of Abraham Maslow*, 2nd edn (New York: McGraw-Hill, 1999), 9.

2 "Dr. Abraham Maslow, Founder of Humanistic Psychology, Dies," *New York Times*, June 10, 1970, 47.

3 Edward Hoffman, "Abraham Maslow: A Biographer's Reflections," Journal of Humanistic Psychology 48, no. 4 (2008): 439–43.

4 Steven J.,Haggbloom et al., "The 100 Most Eminent Psychologists of the 20th Century," *Review of General Psychology* 6, no. 2 (2002): 139–152, doi:10.1037/1089-2680.6.2.139.

5 Abraham H. Maslow, "A Theory of Human Motivation," *Psychological Review* 50, no. 4 (1943): 370–96.

6 Frederick Herzberg et al., *The Motivation to Work* (New Brunswick, NJ:Transaction Publishers, 1993), 32.

7 F. K. Bellott and F. D. Tutor, "A Challenge to the Conventional Wisdom of Herzberg and Maslow Theories," presentation, Annual Meeting of the Mid-South Educational Research Association, New Orleans, LA, 1990, 85.

8 Douglas McGregor, *The Human Side of Enterprise*, annotated edition (New York: McGraw-Hill, 2006), 43.

9 Google Scholar, "Maslow 'A Theory of Human Motivation,'" accessed October 5, 2015, https://scholar.google.com.

SECTION 1
INFLUENCES

THE AUTHOR AND THE HISTORICAL CONTEXT

KEY POINTS

- Abraham Maslow's "A Theory of Human Motivation" is important because it challenged two existing theories of the field of psychology*: psychoanalysis* and behaviorism.*

- Maslow was unwilling to accept the representation of human beings as impulsive and unreasonable creatures driven by primitive desires such as sex and aggression.

- Maslow was a proponent of civilized society; he devoted his life to understanding what establishes positive mental health, happiness, and gratification.

Why Read This Text?

Abraham Maslow's "A Theory of Human Motivation" is one of the most significant texts in the field of psychology. Soon after its first publication in the scientific journal *Psychological Review* in 1943, scholars began to embrace Maslow's argument that psychological theories should no longer be premised on studies of the mentally ill or animals. The paper stimulated an important intellectual discussion among psychologists and other social scientists* on the subject of human motivation and behavior, and their implications. Its influence extended beyond the fields of mental health and human potential* (the idea that humans are innately good, with largely untapped ability), inspiring scholars who dealt with organizational productivity and business management [1]

Maslow's notion of human motivation was crucial to the evolution of at least two fields: psychology and organizational management* (the

> 66 Maslow's youthful experience was extremely typical for those of his background, and they inexorably shaped his worldview. I speak from both personal as well as historical knowledge ... The intellectual concerns common to idealistic youngsters from this background were overcoming religious and ethnic prejudices to create a world based on economic justice and universal education. 99
>
> Edward Hoffman, "Abraham Maslow: A Biographer's Reflections"

process of governing organizations in a way that leads to the achievement of strategic objectives). The psychologist Douglas McGregor* and the business theorist Chris Argyris* adapted the theory to reconsider the way in which businesses relate to their employees in Maslow's most significant legacy in the field of business. His work on human motivation has improved management science* (the field that aims to identify and solve problems regarding the operations and efficiency of organizations) and led to more awareness of humanistic* and behavioristic approaches.[2]

Maslow's theories have bolstered the attempts of social scientists to improve harmony between formal organizations and individuals, and many current academic studies are based on the conceptual foundations that he laid down. Theory and practice have influenced each other, with the famous notion of the hierarchy of needs* being adapted to the contemporary realities of management. (The hierarchy of needs is Maslow's understanding that we are motivated to act by our requirement to satisfy a series of hierarchical needs, starting with essential demands for our survival and safety and finishing with our need for self-actualization*—the achievement of our potential.)

Ultimately, Maslow's motivation theories, and their implications for human behavior, have progressively embraced the more modern applications of organizational management science.

Author's Life

The oldest of seven children, Maslow was born into a family of uneducated Russian Jewish immigrants in Brooklyn on April 1, 1908. After immigrating to New York, Maslow's father had established himself as a successful small businessman, and he encouraged his son to work hard and better himself through education. After completing his primary education, Maslow seemed to flounder while attending New York City College and Cornell University, before finally settling on the study of psychology at the University of Wisconsin, where he went on to earn his BA in 1930, his MA in 1931, and his PhD in 1934.

Maslow trained to be an experimental psychologist (someone who conducts psychological research using scientifically measurable results rather than theory alone) in Wisconsin, where he was introduced to the theory of psychoanalysis,* developed by Sigmund Freud,* and to John Watson* and Ivan Pavlov's* theories of behaviorism. Maslow's professors were all keen behaviorists, concerned with the ways in which behavior was learned and could be altered. They encouraged him to study "lower animals like white rats"—but he felt that monkeys, being genetically closer to humans, were more appropriate subjects. His doctoral dissertation examined the role that dominance and sexuality played in the social behavior of monkeys.[3]

During his early career, Maslow was fortunate to have encountered a wide range of influential psychologists such as Alfred Adler,* Ruth Benedict,* and Max Wertheimer,* who would influence the direction of his research. Through their mentorship, the direction of Maslow's research shifted towards exploring the notion of self-actualization,* which he would go on to develop in "A Theory of Human Motivation."

Maslow died in California in June 1970, aged 62, after suffering a heart attack while jogging.

Author's Background

World War II left a deep impression on Maslow's reasoning, affecting the way he viewed the social and economic (socioeconomic*) environment and the way in which humans react to environment and events.[4] His life history played a significant role in his personal and professional development, establishing him as a person with strong ideals and orientation—but would also be expressed in his firm disagreement with the established theories held in the field of psychology in the first half of the twentieth century.[5]

After relocating to New York City following the completion of his doctorate, Maslow was fortunate to get to know Alfred Adler on a personal level. As his biographer Edward Hoffman* points out, "Adler strongly influenced Maslow in arguing that people have an inborn impulse to be caring, helpful and altruistic—what Adler called social feeling—and are not inevitably seething with repressed selfish, sexual and aggressive impulses as Freud had contended."[6] This seemed to resonate with Maslow, who "became convinced for the rest of his life that humans are more alike than different around the world, and that universal … criteria are discoverable for determining mental health as well as pathology."[7] This view, in turn, put him distinctly at odds with the behaviorist theories prevailing at that time.

Maslow was an advocate of civilized society; he devoted his lifetime to understanding what establishes positive mental health, happiness, and gratification. Although he did not reject the theories of psychoanalysis or behaviorism outright, his newfound orientation was a departure from the established schools of thought. He defended the view that people are motivated and guided by desires dependent on dominant external forces. This, he argued, created a sense of urgency towards a particular desire—or balancing force—that counteracted external pressures in an attempt to achieve equilibrium. Put simply, we act to resolve our wants in the hierarchy of needs.

NOTES

1 Chris Argyris, *On Organizational Learning,* 2nd edn (Oxford: Blackwell, 1999), 73; Douglas McGregor, *The Human Side of Enterprise,* annotated edition (New York: McGraw-Hill, 2006), 43; and Abraham H. Maslow, "A Theory of Human Motivation," *Psychological Review* 50, no. 4 (1943): 370–96.

2 John B. Watson, "Psychology as the Behaviorist Views It," *Psychological Review* 20 (1913): 158–77.

3 Edward Hoffman, "Abraham Maslow's Life and Unfinished Legacy," *Japanese Journal of Administrative Science* 17, no. 3 (2004): 133.

4 Edward Hoffman, "Abraham Maslow: A Biographer's Reflections," *Journal of Humanistic Psychology* 48, no. 4 (2008): 439–43.

5 Hoffman, "Abraham Maslow," 439–43.

6 Hoffman, "Abraham Maslow," 133.

7 Hoffman, "Abraham Maslow," 134.

MODULE 2
ACADEMIC CONTEXT

KEY POINTS

- The primary concern of the field of psychology* is to understand and explain why people act the way that they do, according to the workings of the human mind.

- Prior to the publication of "A Theory of Human Motivation," there were two dominant schools of thought: psychoanalysis,* which concentrates on the unconscious mind; and behaviorism,* which concentrates on the explanation of observable behavior.

- Abraham Maslow's work is significant because it introduced the notion of a third force in psychology— humanism,* a concept founded on the belief that individuals are inherently good.

The Work in its Context

Abraham Maslow's paper "A Theory of Human Motivation" falls within the field of psychology. Since antiquity, however, psychology has been considered to lie within the realm of philosophy rather than of science. Great thinkers such as the ancient Greek philosopher Plato* and his equally influential student Aristotle* pondered the nature of thought and how the mind works. Throughout history, sections of all populations have been afflicted with mental disorders of one kind or another, which has prompted various efforts to explain them. In the fourth century B.C.E., for example, the ancient Greek physician Hippocrates* argued that mental disorders were not the product of supernatural intervention, such as demonic possession, but had physical causes.

During the Enlightenment* (the eighteenth-century philosophical

> ❝ Maslow was thus far more comfortable with the practical, socially oriented approach of Alfred Adler … Maslow conducted his doctoral dissertation at the University of Wisconsin to verify Adler's conception of social dominance, and in a very real sense, Maslow can be seen as an Adlerian drawn primarily to issues of growth and achievement rather than family dynamics. ❞
> Edward Hoffman, "Abraham Maslow: A Biographer's Reflections"

and political movement that questioned the irrationality of traditional belief, advancing knowledge through scientific methods), the nature of the mind and of thought became a topic of discussion among philosophers like the German thinker Immanuel Kant,* who developed the notion of a philosophy of the mind. It was not until the 1870s that psychology broke away from philosophy to become a discipline of its own, when the German psychologist Wilhelm Wundt* built a laboratory to conduct experiments, approaching the study of the mind as a science instead of a matter of philosophy. After first gaining acceptance in Germany, psychology soon found fertile ground in the United States in the 1880s and emerged as a discipline in its own right by the 1890s, when the Austrian physician Sigmund Freud* introduced the concept of psychoanalysis. Not long after this, the field of psychology split into two schools of thought, following the introduction in 1904 of the Russian psychologist Ivan Pavlov's* theory of behaviorism, and subsequent developments made soon after by John Watson.*

Overview of the Field
"A Theory of Human Motivation" is significant because Maslow sought to challenge the two dominant psychological schools of thought: psychoanalysis and behaviorism.

Psychoanalysis focused on human desire and the unconscious mind; Freud developed the approach's theoretical underpinnings by examining people with mental conditions. Maslow argued that focusing on people with mental conditions was insufficient, because only a minority of the world's population suffers from this type of affliction.

The other dominant school at the time Maslow wrote his text was behaviorism, which concentrated on the process of learning and formed its key theoretical suppositions from observations of animals, mainly primates (the order of mammals that includes chimpanzees and humans). Developed in the early twentieth century, this view holds that human and animal behavior can be explained by the conditions in which the subject was raised. A notable proponent of this view was the Russian psychologist Ivan Pavlov, who became famous for his experiments with dogs. Noting that dogs salivated when given food, he provided a stimulus, like hitting a tuning fork, prior to feeding; over time, the dogs in his study would salivate just on hearing the sound. This is known as conditioning.*[1]

Maslow's theory, known as humanistic psychology* or, more simply, humanism, straddled the previously established theories. Instead of focusing on negative connotations, humanism emphasized the inherent good in people and their drive towards self-actualization* (that is, the realization of their full potential).

Academic Influences

Maslow's work was influenced by mentors such as Alfred Adler* at Columbia University, and later the US anthropologist Ruth Benedict* and the Austro-Hungarian psychologist Max Wertheimer,* who inspired him to devote his work to better understanding the notion of self-actualization.

Maslow's research focus has been defined as humanistic, because of his emphasis on the value of human beings, individually and collectively. This approach differed significantly from the status quo in

psychology, which focused on the biological aspects of human nature. Contributing to the fields of mental health and human potential,* Maslow built upon other psychologists' work concerning notions such as metaneeds* (that is, human needs that go beyond basic physiological* requirements for food and shelter), metamotivation* (people's motivation to achieve something beyond their basic needs), and self-actualization. After researching these concepts, Maslow used "A Theory of Human Motivation" to introduce a new framework for the study of psychology, "the hierarchy of needs,"* which he used to explain complex human behavior and its characteristics.

In doing so, Maslow introduced a third force into the field of psychology, further developed in the work of the American psychologists Gordon Allport* and Carl Rogers.* These scholars believed that people, by their very nature, are good; that they follow a logical developmental route; and that they are driven by conscious attitudes to achieve self-actualization. The established theory supports the view that the process of personal development is not only an innate characteristic of human behavior; pursuing self-actualization helps to form a healthy society.

NOTES

1 Nobel Prize Organization, *"Ivan Petrovich Pavlov (1849–1936),"* accessed September 23, 2015, http://www.nobelprize.org/educational/medicine/pavlov/readmore.html.

MODULE 3
THE PROBLEM

KEY POINTS

- The primary focus of the field of psychology* is the human mind—how it functions and what brings about mental illness.

- Prior to the publication of "A Theory of Human Motivation," there were two primary approaches to psychology: psychoanalysis* and behaviorism.*

- Abraham Maslow differed from these views, arguing that people were inherently good and that human behavior can be explained by a person's innate desire for personal and professional growth.

Core Question

Challenging the existing schools of psychoanalysis and behaviorism, Abraham Maslow's "A Theory of Human Motivation" developed a new approach to the study of psychology. The central question that Maslow asks in "A Theory of Human Motivation" is "What provokes behavior?" His answer described both external and internal forces— physiological,* sociological,* and psychological*—that shape the way people respond to environmental pressures. Physiological forces are a matter of the physical organism; sociological forces are associated with society; psychological forces have to do with the workings of the human mind.

Maslow concluded that certain needs are inherent to all human beings. He broke these into two categories:

- Basic needs (notably physiological needs and needs for safety, love, and esteem).Is civic engagement in America indeed declining?

> **❝** Anticipating later evolutionary views of human motivation and cognition, Maslow viewed human motives as based in innate and universal predispositions. **❞**
> Douglas T. Kenrick et al., "Renovating the Pyramid of Needs"

- Growth needs (notably the need for self-actualization*—the realization of one's full potential).[1] What ramifications does it have for society?

While critics objected to the hierarchical structure of needs as he presented it, his theory still has value for a contemporary understanding of society and its dynamics.

"A Theory of Human Motivation" was published in 1943, a key period in the development of psychology as a discipline. The two dominant approaches to the study of human behavior at the time were psychoanalysis and behaviorism. Whereas psychoanalysis tended to focus on explaining an individual's conflicts and desires, using people with mental illnesses as subjects, behaviorism looked at the process of learning and derived its assumptions and theories from studies conducted on animals. Maslow felt both models failed to take into consideration the inherent good in human nature, and developed an alternative theory that took this into account.

The Participants

When Maslow published "A Theory of Human Motivation," the field was dominated by those who subscribed either to Sigmund Freud's* psychoanalytical model or Ivan Pavlov's* behaviorist/conditioning* model. For Maslow, neither of these approaches offered a complete explanation for what motivates people to act a key question perplexing to psychologists and philosophers for many years.

After the emergence of psychology as a field of study in its own

right in Germany in the late 1880s, Freud's work developed the first major psychological theory: psychoanalysis. Freud believed that people afflicted with certain mental conditions needed to be treated using psychotherapy,* where they would relate their thoughts, fears, sexual fantasies, and dreams to a psychotherapist, who could interpret them to help the patient find a way to resolve their affliction. The key here is that the focus of Freud's work was on people who were mentally ill.

The problem with Freud's theory, according to the Russian psychologist Pavlov, was that it does not take account of conditioning: the trained response to a stimulus. In experiments with dogs, Pavlov showed that he could elicit a physiological response from an animal based on exposure to stimuli. While Maslow agreed that Pavlov's work was important and relevant, he disagreed with the use of animals to help explain human actions, arguing, "Motivation theory should be human-centered rather than animal-centered."[2]

In the early twentieth century, the US psychologist John Watson* developed Pavlov's ideas further into a distinct school of thought— behaviorism—in the article "Psychology as the Behaviorist Views It" (1913) and in the book *Behaviorism* (1924).[3] Arguing that research should focus only on what can be observed, Watson's approach to psychology was much more "positivist"* than that of Freud or Pavlov. He famously showed that Pavlov's conditioning could be applied to humans in his 1920 "Little Albert" experiment, in which he tested the hypothesis that fear was a conditioned response. He did this by showing a white rat to Little Albert, an infant of almost a year. The boy displayed no fear at the sight of the rat but burst into tears at the accompanying sound of a sudden loud noise. This was repeated several times over a period of weeks, until just the sight of the rat made the boy cry. Subsequent experiments demonstrated that a phobic reaction could be caused by other objects with rat-like characteristics, such as a white rabbit and a white fur coat. This experiment, while

considered unethical by today's standards, showed that emotions are a conditioned response.[4]

The Contemporary Debate

In the period prior to World War II,* the field of psychology had entered a lull, with psychoanalysis and behaviorism standing out as the two main schools of thought. When Maslow began to reconsider these approaches, he noticed that these theories were not particularly applicable to the wider population whereas his own theories were.

Maslow was not the only psychologist looking into the question of what motivated people to do things. A few years prior to the publication of Maslow's theory, another psychologist, the US scholar Gordon Allport,* published a study on personality traits. After going through an English dictionary and identifying words used to describe people, Allport identified three common categories: cardinal traits,* which dominate a person's character (being obsessed with success, for example); central traits,* which form the core of a person's personality (honesty, selfishness, intelligence, for example); and secondary traits,* which only become present during certain circumstances (such as being picky or a coward).[5] Allport's work led to the emergence of trait theory,* an approach to exploring the human personality by measuring patterns of thoughts and behavior.

Another of Maslow's contemporaries was the psychologist Carl Rogers,* whose work focused more on the clinical side of psychology than the theoretical. Early in his career, Rogers worked closely with troubled children. His clinical work eventually resulted in his first publication, *The Clinical Treatment of the Problem Child* (1939), in which he advocated a "client-centered" approach that built on Freud's psychoanalytical method. (A client-centered approach begins with the therapist's unconditional acceptance of, and empathy with, his or her client, or patient.) Along with Maslow, Rogers put forward a new approach to psychology, humanistic psychology* (or humanism*),

which holds that people are inherently good and which pushes patients to recognize their own self-worth.

Together, Maslow, Allport, and Rogers emphasized that an aspiration towards development and growth exists within human nature. With its focus on realizing untapped capacity, this new humanistic theory, the most significant alternative to psychoanalysis and behaviorism, spawned the human potential movement* between 1960 and the mid-1970s.

NOTES

1 Abraham H. Maslow, "A Theory of Human Motivation," *Psychological Review* 50, no. 4 (1943): 370–96.

2 Maslow, "Theory of Human Motivation," 371.

3 John B. Watson, "Psychology as the Behaviorist Views It," *Psychological Review* 20 (1913): 158–77; and *Behaviorism*, 7th edn (New York: Transaction Publishers, 1998).

4 John B. Watson and Rosalie Rayner Watson, "Studies in Infant Psychology," *Scientific Monthly* 13, no. 6 (1921): 493–515.

5 Gordon Allport, *Personality: A Psychological Interpretation* (New York: Henry Holt & Co, 1937).

MODULE 4
THE AUTHOR'S CONTRIBUTION

KEY POINTS

- Abraham Maslow was not convinced that human behavior is driven by repressed desires or is a product of conditioning* (as Freudian* psychoanalysis* or behaviorism,* respectively, would argue); instead, he believed that humans are inherently good by nature and that their behavior is driven by a necessity to satisfy their basic needs.

- With "A Theory of Human Motivation," Maslow challenged the two existing approaches of psychology* and introduced a new model, humanistic psychology,* which held that human nature is not animalistic* (that is, fundamentally like the instinctive behavior of animals).

- While Maslow's work built upon the German psychiatrist Kurt Goldstein's* concept of self-actualization,* the way he broke down the primary motivations of human behavior into five broad categories—physiological,* safety, love, self-esteem, and self-actualization—was novel.

Author's Aims

The primary objective of Abraham Maslow's "A Theory of Human Motivation" was to reconsider how best to approach psychology. The text proposed a new psychological theory that went beyond the major theories of psychoanalysis and behaviorism that dominated the field in 1943. In Maslow's view, human personality theory* (the study of patterns of human nature, with emphasis on people's differences and similarities) was inadequate for explaining conscious motivation* (being fully aware of the desire to conduct an activity). He was determined to make a difference by introducing the perspective of

> 66 His seminal 'hierarchy of inborn needs' model appeared in the mid–1940s. More than a decade would pass before Maslow began formally presenting the specific qualities he found among self-actualizers, including their frequent peak experiences, attraction for creative work, and yearnings for world betterment. 99
>
> Edward Hoffman, "Abraham Maslow: A Biographer's Reflections"

humanism to the existing theory. By diverging from the mainstream, he succeeded in achieving his aims. This article, his first, resonates through the decades—sound evidence that he revolutionized his field.

Along with the psychologists Gordon Allport* and Carl Rogers,* Maslow supported and tried to promote the conviction that humans are virtuous by nature, that individuals have a rational path of self-development, and that they are guided by conscious desires to attain self-actualization. "A Theory of Human Motivation" succeeded in promoting a coherent humanistic theory of behavior. Due to this success, Maslow has been portrayed as a prominent innovator in the field.[2]

Maslow has been seen as an active opponent of psychoanalysis and of behaviorism for his objection that these theories tend to represent people as aggressive and animalistic. These prevailing views received partial credibility from historical events—after all, Maslow wrote his text in the middle of World War II.* But the horrors of war convinced Maslow that human nature is not animalistic, and that these events should not serve as a justification of psychoanalysis and behaviorism. For that reason, he concentrated on analyzing "peak experiences"— exalted moments of great creative power, among which were events of happiness. This facilitated his theoretical justification of the rational nature of human beings and served as the foundation of the third wave in psychology: humanism.[3] The realization of Maslow's aims through his influential work "A Theory of Human Motivation" established his

ideas as credible and inspired other scholars to follow and expand the humanistic orientation in psychology.

Approach

By introducing notions such as metaneeds,* metamotivation,* a hierarchy of needs,* and self-actualization, Maslow built upon the work of other psychologists and made a major contribution to the fields of mental health and human potential.* His most distinguished and influential work, "A Theory of Human Motivation" was based on a wealth of study, and its central concepts established Maslow's reputation.

The originality of Maslow's work stems from his answer to a question long fundamental to the field of psychology: why do people behave in certain ways? Before the work was published, the multidimensional nature of human beings and the numerous dynamics they are exposed to made answering this question almost impossible, as any of these forces can provoke an individual to behave in a particular way. Maslow concluded, however, that people's behavior is shaped by internal pressures, emerging from human nature, and external pressures exerted by the environment.

Maslow's answer to this question represented a milestone in psychology, creating an important framework used by psychologists as a springboard for further explanation of complex human behavior and its characteristics. The essay's significance is evident in the fact that it continues to be hailed as a leading text in the field of psychology. The work's wide acceptance in diverse academic disciplines demonstrates its enormous impact on contemporary academia.

Contribution in Context

As with most works in its field, Maslow's theory builds on the intellectual scaffolding put in place by the two dominant schools of thought. To Maslow, both psychoanalysis and behaviorism were key to his

33

development as a psychologist, notwithstanding their evident deficiencies.

The original spirit of Maslow's work highlighted the humanistic nature of people and the rationality of their desires, which proved to be constructive to society rather than instigated by aggression, as Freud had suggested. Today, although the socioeconomic* context has evolved and society emphasizes the importance of developing and pooling knowledge, the spirit of Maslow's work lives on.

Through the theory of self-actualization, to which Maslow contributed, managers have realized that employees are creative and produce the sort of knowledge that transfers into market efficiency only when their needs are satisfied. Due to Maslow's coherent theoretical impact, built upon the work of predecessors (notably Kurt Goldstein and Carl Rogers), it is no longer a surprise that (apart from monetary incentives) employees need recognition and the potential to achieve self-actualization in order for their creativity and effectiveness to flow freely.[4] In this way, Maslow's humanistic legacy developed into a consensus regarding psychological theory in the management of organizations and psychology.

NOTES

1 Edward Hoffman, *The Right to be Human: A Biography of Abraham Maslow*, 2nd edn (New York: McGraw-Hill, 1999), 53.

2 Edward Hoffman, "Abraham Maslow: A Biographer's Reflections," *Journal of Humanistic Psychology* 48, no. 4 (2008): 439–43.

3 Abraham H. Maslow, "A Theory of Human Motivation," *Psychological Review* 50, no. 4 (1943): 370–96.

4 Kurt Goldstein, *The Organism: A Holistic Approach to Biology Derived from Pathological Data in Man* (Cambridge, MA: Zone Books/MIT Press, 2000), 126.

SECTION 2
IDEAS

MODULE 5
MAIN IDEAS

KEY POINTS

- The key themes of "A Theory of Human Motivation" relate to the five basic needs identified in the text: physiological,* safety, love, self-esteem, and self-actualization.*

- Abraham Maslow argues that basic human needs are arranged in a hierarchical fashion, with physiological and safety needs being essential for survival, while love, self-esteem, and self-actualization emerge in varying degrees after the essential needs are relatively satisfied.

- Maslow shows that individuals follow a logical developmental route and are driven by conscious attitudes for achieving self-actualization.

Key Themes

There are five sets of goals identified by Abraham Maslow in "A Theory of Human Motivation" as basic needs: physiological needs, safety, love, esteem, and self-actualization. He arranges these hierarchically, with physiological needs being the most important and self-actualization the least.

Physiological needs are the things a person needs to survive, like food and water. Your body physically requires these substances to live. Maslow believes that when all other factors are stripped away, a person's basic instinct is to find food and water—nothing else matters. He believes that a desire for safety is also one of the primary organizers of organisms, whether people or animals. Safety exists in groups, and for groups to function they need to be organized. For the most part, the need for safety—from animals, extreme temperatures, tyranny—is

> ❝ Human needs arrange themselves in hierarchies of prepotency. That is to say, the appearance of one need usually rests on the prior satisfaction of another, more prepotent need. Man is a perpetually wanting animal. ❞
>
> Abraham H. Maslow, "A Theory of Human Motivation"

satisfied, but for those who live in poverty, the need for safety—to find a job, to live in a safe neighborhood—is pressing.

Once both physiological and safety needs are met, other secondary needs emerge.

The next requirement is for love, affection, and belongingness. The rejection of this need, Maslow points out, is the most common cause of cases of maladjustment and severe psychopathy* (mental disorder in which an individual displays amoral and antisocial behavior).

Next in the hierarchy of needs, Maslow argues, is the need to be respected by others, to have self-esteem, and to give respect to others. He breaks esteem down into two categories: first, the desire for strength, achievement, adequacy, and confidence; and second, the desire for a good reputation, prestige, or recognition.

The final need in Maslow's hierarchy is self-actualization—the need to achieve one's potential. The concept of self-actualization is not unique to Maslow, as it was first introduced by German psychiatrist Kurt Goldstein* in his work *The Organism* (1939). Maslow is intentionally vague about the precise nature of self-actualization needs, because it is rare to find someone who has achieved everything that they have sought to achieve.

Exploring the Ideas

Before going deeper into these concepts, it is important to note that Maslow's theory is not sequential. It does not mean that just because

"one need is satisfied, then another emerges." As Maslow warns, "This statement might give the false impression that a need must be satisfied 100 percent before the next need emerges. In actual fact, most members of our society who are normal, are partially satisfied in all their basic needs and partially unsatisfied in all their basic needs at the same time." With this in mind, Maslow argues that a "more realistic description of the hierarchy would be in terms of decreasing percentages of satisfaction as we go up the hierarchy of prepotency."[1]

Maslow explains that physiological needs are the most primal. Using the example of a person "who is missing everything in life in an extreme fashion," Maslow believes that physiological needs will be their primary motivator, above any other. "A person who is lacking food, safety, love, and esteem would most probably hunger for food more strongly than for anything else."[2]

Once physiological needs have been satisfied, even if only partially, the need for safety emerges as next important. Maslow views safety as "an active and dominant mobilizer of [our] resources only in emergencies" such as war, disease, natural catastrophes, or crime waves.[3] Maslow argues that safety is essential to raising well-adjusted children, pointing out that children require "a safe, orderly, predictable, organized world," where "unexpected, unmanageable or other dangerous things do not happen," and, should they occur, they should have "all-powerful parents who protect and shield [them] from harm."[4]

Love is an important need. If a person feels loved, they are better able to play a productive role in society. As Maslow points out, "Love and affection, as well as their possible expression in sexuality, are generally looked upon with ambivalence and are customarily hedged about with many restrictions and inhibitions."[5] This is problematic, because the "thwarting of the love needs" contributes significantly to maladjustment.[6]

Esteem is also important. Maslow argues that "satisfaction of the self-esteem need leads to feelings of self-confidence, worth, strength,

capability and adequacy, of being useful and necessary in the world. Thwarting of these needs however, produces feelings of inferiority, of weakness and of helplessness."[7]

Finally, Maslow explains that self-actualization stems from a nagging desire to accomplish something in one's life. "A musician must make music, an artist must paint, a poet must write, if he is to be ultimately happy. What a man *can* be, he *must* be."[8] Self-actualization is something that only a small minority of the population ever achieve. Problematically, as Maslow acknowledges, "we do not know much about self-actualization, either experimentally or clinically. It remains a challenging problem for research."[9]

Language and Expression

One of the most successful elements of Maslow's essay is the way in which he conveys his ideas. For the most part, the text's language is easily understood, though there are more difficult passages dealing with subject-specific material and theory. At the same time, the article is clearly written for a specialist audience, as it introduces several concepts to the psychological lexicon, like self-actualization, metaneeds,* and metamotivation.* This makes sense, as the original purpose of the text was to introduce a new theory of psychology.*

The article is at its strongest when giving examples of basic needs. For instance, when describing physiological needs, Maslow regularly refers to a person who is hungry. "For the man who is extremely and dangerously hungry, no other interests exist but food. He dreams food, he remembers food, he thinks about food, he emotes only about food, he perceives only food and he wants only food."[10] This short excerpt exemplifies the relatively simple language that Maslow employs to make his point. It is perhaps for this reason that the text has been so successful in reaching a wide audience.

NOTES

1 Abraham H. Maslow, "A Theory of Human Motivation," *Psychological Review* 50, no. 4 (1943): 388.

2 Maslow, "Theory of Human Motivation," 373.

3 Maslow, "Theory of Human Motivation," 379.

4 Maslow, "Theory of Human Motivation," 378.

5 Maslow, "Theory of Human Motivation," 381.

6 Maslow, "Theory of Human Motivation," 381.

7 Maslow, "Theory of Human Motivation," 382.

8 Maslow, "Theory of Human Motivation," 382.

9 Maslow, "Theory of Human Motivation," 383.

10 Maslow, "Theory of Human Motivation," 374.

MODULE 6
SECONDARY IDEAS

KEY POINTS

- The key secondary ideas of "A Theory of Human Motivation" are Maslow's challenges to the previous schools of psychology* (psychoanalysis* and behaviorism*); his emphasis that humans needs can never be fully satisfied; and his belief that mental illness is due to a failure to satisfy basic needs.

- By challenging the previous paradigms of psychology and introducing a new theory as to why people develop mental illnesses, Maslow established humanistic psychology* as a new model in the field of psychology.

- The most important secondary idea is Maslow's view that humans are inherently good by nature, a view that posed a direct challenge to earlier theories developed by studying the mentally ill (psychoanalysis) or animals (behaviorism).

Other Ideas

In addition to introducing his hierarchy of needs,* Abraham Maslow's "A Theory of Human Motivation" challenges the intellectual basis of psychoanalysis and behaviorism. It also emphasizes the importance of viewing humans as a "perpetually wanting animal,"[1] and puts forward an explanation for the occurrence of psychopathy.*

Given that Maslow was proposing a new theory of psychology, it makes sense that his theory would have to reject the central components of psychoanalysis and behaviorism and offer a viable alternative. Maslow makes clear his view that the subjects of Freud and Pavlov's research are inherently flawed. In Freud's case, the subjects used to develop his theory of psychoanalysis were mental patients,

> ❝ At the core of Maslow's theory of motivation are two important ideas: (a) there are multiple and independent fundamental motivational systems and (b) these motives form a hierarchy in which some motives have priority over others. ❞
>
> Douglas T. Kenrick et al., "Renovating the Pyramid of Needs"

who statistically make up only a small portion of the population. Likewise, the subjects that Pavlov used to develop his theory of behaviorism were animals, which Maslow believed were not really representative of humans. To Maslow, using either a minority within the wider population or animals to develop theories that are meant to explain people's motivations seemed preposterous. Instead, he believed that healthy, normal humans should be the basis for developing a viable psychological theory.

Another secondary idea of "A Theory of Human Motivation" is the notion that humans are a perpetually wanting animal. This means that once one need is satisfied another—higher—need soon takes its place. For example, consider a starving person who has just survived a natural disaster. Their immediate concerns might be to find their loved ones and make sure they are safe, but before long their survival will depend on satisfying their physiological* needs (that is, finding a source of food and water). Once that is achieved, their thoughts can then turn to finding safety. Maslow believes that only when their physiological and safety needs are met can they begin to devote themselves to satisfying their need for love, esteem, and self-actualization.*

Finally, Maslow makes a strong case that the thwarting of the basic needs is a primary cause for psychopathy. In this argument, Maslow appears to draw on elements of Freud's psychoanalytical model. However, Maslow differs in pointing out that the deprivation of one

of the basic needs does not always have to occur in childhood, as Freud would suggest. For example, it is possible for a person who has always lived in a loving family to become psychotic if their spouse leaves them without warning. Suddenly deprived of love and without a support system, they could become depressed or develop worse symptoms, all of which might have nothing to do with their childhood.

Exploring the Ideas

Maslow's theory of human motivation puts forward a strong case that the subjects of psychological studies should not be mental patients (as in the theories of Freud) or animals (as shown by Pavlov), but instead normal, healthy humans. In particular, he suggests that applying findings developed from the study of animals to humans is misguided: "Too many of the findings that have been made in animals have been proven to be true for animals but not for the human being."[2] He points out that countless scientists, philosophers, and logicians (experts in the study of logic) have made this same point, arguing that it is "no more necessary to study animals before one can study man than it is to study mathematics before one can study geology or psychology or biology."[3]

Maslow also makes a strong case for his argument that man is a perpetually wanting animal. He is correct in claiming that "when a need is fairly well satisfied, the next prepotent ('higher') need emerges, in turn to dominate the conscious life and to serve as the center of organization of behavior, since gratified needs are not active motivators."[4] Governments typically satisfy the physiological and safety needs of their citizens through social welfare programs, healthcare, police and fire services, and unemployment benefits. As a result, most people tend to focus on satisfying their need for love, esteem, and self-actualization because their baser needs are already provided for. However, in other parts of the world, where poverty and crime are rampant, physiological and safety needs predominate. As Maslow explains, "our needs usually emerge only when more prepotent needs have been gratified."[5]

Maslow's most provocative argument is that the thwarting of—or the possibility of thwarting—these basic needs is to be considered a psychological threat. "With a few exceptions," Maslow argues, "all psychopathology* [disorders of the mind] may be partially traced to such threats."[6] For example, if a child is starved throughout its youth, it might develop neurosis (a mild mental illness) out of a fear that food might be taken away; or a person who has never been loved might never develop emotions; or a person who is rejected continuously from a group of peers might become a mass murderer.

Overlooked

"A Theory of Human Motivation" is a short article of only 26 pages. As one of the most significant intellectual frameworks for the understanding of research data, countless scholars have picked it apart; little, then, has been overlooked. That said, Maslow makes a point of directing his readers, and future scholars, toward aspects of his theory that he believes need further research, listing 13 "basic problems" at the text's conclusion that "have not been dealt with because of limitations of space."[7]

This list of "basic problems" includes the necessity to differentiate between "appetites," "desires," "needs," and what is right for the organism. It is still not clear how each one of these factors can influence human motivation; perhaps further research can examine whether the motivation that these factors exert on human behavior differs from the behavior outlined by Maslow. It is possible that "appetites," "desires," and "needs" are intertwined—in which case we require a more encompassing and comprehensive model of human motivation.

Another point remaining overlooked is Maslow's suggestion that scholars examine the role of context—culture and social class, for example—in the development of basic needs in early childhood. The study of context will allow scholars to address the formation of intentional processes (that is, motivation) in all its complexity, both

assisting the development of new theories of motivation and offering opportunities for research less influenced by the biases of the researcher.

This list aimed to open up new, fertile ground for researchers interested in the ideas Maslow put forward in his article. In its light, it is worth acknowledging that although humanism* has become established as a mainstream school of thought (displacing psychoanalysis and behaviorism), the field of humanistic psychology* cannot be complete without capturing all complexities associated with human motivation.

NOTES

1 Abraham H. Maslow, "A Theory of Human Motivation," *Psychological Review* 50, no. 4 (1943): 395.

2 Maslow, "Theory of Human Motivation," 392.

3 Maslow, "Theory of Human Motivation," 392.

4 Maslow, "Theory of Human Motivation," 395.

5 Maslow, "Theory of Human Motivation," 393.

6 Maslow, "Theory of Human Motivation," 395.

7 Maslow, "Theory of Human Motivation," 395.

ACHIEVEMENT

KEY POINTS

- Abraham Maslow's "A Theory of Human Motivation" established humanistic psychology* as a third force in the field of psychology.*

- The most important factor contributing to the success of the work was the growing acceptance that previous conceptual frameworks in the field of psychology were difficult to apply to the wider population, and could not explain conscious motivation.*

- The most significant factor limiting the success of the text was that Maslow's concept of self-actualization* was somewhat ambiguous and difficult to qualify in clinical studies.

Assessing the Argument

When Abraham Maslow set out to write "A Theory of Human Motivation," he knew he had to present his hierarchy of needs* in a practical and easily understood fashion. To this end, his article has been a resounding success. Not only did it go on to generate an entirely new school of thought within the field of psychology, but Maslow successfully posed a challenge to Sigmund Freud's* psychoanalysis* and the behaviorism* of Ivan Pavlov* and John Watson.*

While Maslow views these two schools of thought as the scaffolding of the field of psychology, he felt they both had limited relevance to the actual behavior and unconscious drives of mentally healthy people. In short, he felt they studied the wrong subjects:

❝ This theory starts with the human being rather than any lower and presumably 'simpler' animal. Too many of the findings that have been made in animals have been proven to be true for animals but not for the human being. There is no reason whatsoever why we should start with animals in order to study human motivation. ❞

Abraham H. Maslow, "A Theory of Human Motivation"

mentally unhealthy people and animals. To Maslow, and those who follow him, the ideal subject for the study of psychology is a normal, mentally healthy person. By setting the baseline for experimentation in this place, Maslow's theory was able to elicit a clearer understanding of what motivates human beings. He saw that people were driven by baser needs, with physiological* and safety needs being the most essential, followed by love, esteem, and self-actualization. The degree of importance varies within each of these categories, though this is dependent on the nature of the person in question. Nevertheless, Maslow was successful in establishing an entirely new school of thought—a third force—within the field of psychology.

Achievement In Context

"A Theory of Human Motivation" was published in 1943, in the middle of World War II.* While the United States had remained neutral for the first few years of the war, the Japanese attack on its naval base at Pearl Harbor* in December 1941 changed everything; the US declared war not just on Japan but on Nazi Germany* as well. This meant that the United States was fighting two separate wars simultaneously, which required devoting all of the resources that could be mustered to help the war effort. This is known as "total war."*

Given these circumstances, the success of Maslow's article is remarkable—but it made sense, too. The central theory that Maslow

put forward was fitting because of the scale of violence and deprivation endured both at the front lines and at home. Food, for example, was not as plentiful as during times of peace, and so the notion that humans were driven by the fulfillment of their basic needs was thought-provoking and persuasive. It also helped war planners design strategies that could contribute to the defeat of their enemies through depriving their populations of basic needs, particularly in cutting off access to food and by terrorizing them with bombing raids. Similarly, after the war, Maslow's theory was helpful to administrators trying to rebuild a shattered Europe and East Asia through the provision of food, security, and economic aid. Given these circumstances, the success of Maslow's article was driven by the demands of leaders for fresh ideas.

Limitations

Although Maslow's text put forward a new theory of psychology, it had an enduring impact on several other academic fields, like military strategy, management studies,* and international development* (the effort to provide a higher standard of life for the citizens of poorer, less-developed nations). Military strategists, like those who planned and executed World War II, took note of Maslow's notion that people who are deprived of their basic physiological and safety needs focus on satisfying these needs above others. Although this is not a unique idea—the Chinese military strategist Sun Tzu* advocated starving an enemy before battle in the sixth century B.C.E.[1]—nevertheless, Maslow's theory confirmed that these basic needs were what motivated people's actions.

Maslow's work also had an impact on management studies, where scholars adapted his model to advocate the abandonment of the classic top-down management approach that focused on workers' productivity, in favor of a model that facilitated the achievement of basic human needs. Such needs might include providing employees with a reasonable salary, job security, social benefits, encouraging

teamwork/socialization, rewarding workers, and finding ways to accommodate their employees' aspirations.[2]

The hierarchy of needs was also relevant to international development, a field that seeks ways to provide people worldwide with their basic needs. In September 2015, for example, the United Nations adopted the sustainable development goals* (an internationally agreed-on set of goals designed to improve the lives of people around the world). The first two objectives—to end poverty in all its forms, and to end hunger and ensure food security—point directly to Maslow's hierarchy of needs.[3]

Because Maslow's theory is universal (that is, it applies to virtually every organism, human or animal), it is not limited to a specific time and place nor is it culturally specific. An individual's religion, nationality, or species is irrelevant: physiological needs will always take precedent over other basic needs such as love or self-actualization.

NOTES

1 See Sun Tzu, *The Art of War*, trans. Lionel Giles, accessed October 13, 2015, http://classics.mit.edu/Tzu/artwar.html.

2 See Abraham H. Maslow, *Eupsychian Management: A Journal* (New York: R.D. Irwin, 1965).

3 United Nations, "Sustainable Development Goals," September 25, 2015, accessed January 19, 2015, https://sustainabledevelopment.un.org/post2015/summit.

MODULE 8
PLACE IN THE AUTHOR'S WORK

KEY POINTS

- The primary focus of Abraham Maslow's body of writings was the development and refinement of his theory of humanistic psychology* and his concept of self-actualization.*

- "A Theory of Human Motivation" was Maslow's first major publication and established the intellectual basis for the rest of his career.

- The name Abraham Maslow and the hierarchy of needs* are virtually synonymous. His entire reputation as a leading psychologist was based on the essay's massive success.

Positioning

Abraham Maslow's "A Theory of Human Motivation" was published as an article in 1943. As his first major publication, "A Theory of Human Motivation" laid the foundation for what would become an impressive body of work, spanning three decades. Indeed, much of Maslow's subsequent work focused on the nature of motivation and supported the theoretical model he put forward at the outset of his academic career.

As the father of an entire school of thought in the field of psychology, Maslow worked hard to refine and popularize his ideas in his subsequent publications. The idea that people search for personal development in everything they do is central to Maslow's body of work. A key theme that runs through his writings is the question of what motivates people. This was particularly evident in his book *Motivation and Personality* (1954), which sought to bridge his own theoretical model with the American psychologist Gordon Allport's*

> ❝ Almost 70 years have passed since Abraham Maslow's classic 1943 *Psychological Review* paper proposing a hierarchical approach to human motivation. Maslow's model had an immense influence on the field of psychology, including the subfields of personality, social psychology, psychopathology, developmental psychology, and organizational behavior, and it continues to be cited widely in textbooks. ❞
>
> Douglas T. Kenrick et al., "Renovating the Pyramid of Needs"

work on personality traits, while at the same time refining his concept of self-actualization. This concept (the discovery of meaning in life) is regarded as the final need that people strive to attain, but to succeed is remarkably rare. After all, a person may seem as if they have achieved everything in life, but could still be unhappy because they have not achieved self-actualization.

The text's success is testament to how advanced and mature Maslow's ideas were at such an early point in his professional development.

Integration

As a whole, Maslow's body of work tends to focus on refining what self-actualization actually is, and then proposing strategies for how to achieve it. For example, in his text *Religions, Values and Peak Experience* (1964), Maslow studied the characteristics of people he believed had achieved self-actualization, such as US president Abraham Lincoln* and physicist Albert Einstein,* in order to identify the key features these people appeared to possess. These included spontaneity, self-acceptance, low aversion to risk, originality of thought and actions, a creative approach to problem-solving, an ability to be objective, selflessness, democratic orientation, strong morality, and peak

experiences—the experience of exalted moments of great creative power.[1]

At the same time, Maslow wanted to show how his theory of motivation could be applied to real-world situations, like the running of a business. In *Eupsychian Management: A Journal* (1965), Maslow developed an alternative model for running a large business. Unlike the top-down model that sought to push workers to achieve higher productivity, Maslow argued that businesses could increase productivity if they sought to ensure the self-actualization of their employees. For example, employees who are paid a living wage (enough to pay rent and buy sufficient food) are going to be more productive than those who struggle to pay their rent or feed their families. Similarly, workers who are encouraged by their bosses to achieve their potential (that is, achieve self-actualization) also tend to work harder than those whose bosses hinder or stifle this basic need.

Significance

When viewing Maslow's body of work as a whole, it becomes clear that it was designed to reinforce the central premises of the theory of human motivation he proposed at the start of his academic career. This, in turn, means that "A Theory of Human Motivation" is by far the single most significant text he produced. The fact that every one of Maslow's subsequent publications is premised on this text, as well as countless other studies from fields as far-ranging as business management to international development,* is a testament to its importance.

Moreover, the essay firmly established Maslow as one of the foremost psychologists of his time. To date, according to Google Scholar, the text has been cited in over 14,000 publications—a remarkable number.[2] More importantly, scholars have continued to update the basic core of Maslow's argument as further research into the motivation of people reveals new findings. For example, in 2010 a group of scholars sought to update and modernize Maslow's hierarchy

of needs. In particular, the group included several reproductive goals, like the acquisition and retention of a mate, while dropping self-actualization in favor of parenting.[3] This confirms the ongoing importance of "A Theory of Human Motivation" both as a source of inspiration for research and as a model for future scholarship.

NOTES

1 Abraham H. Maslow, Religion, Values and Peak Experiences (New York: Penguin Arkana, 1994), 23.

2 Google Scholar, "Maslow 'A Theory of Human Motivation,'" accessed October 5, 2015, https://scholar.google.com/scholar?hl=en&q=maslow+%2 2a+theory+of+human+motivation%22&btnG=&as_sdt=1%2C9&as_sdtp=.

3 Douglas Kenrick et al., "Renovating the Pyramid of Needs: Contemporary Extensions Built upon Ancient Foundations," *Perspectives on Psychological Science* 5, no. 3 (2010): 292–314.

SECTION 3
IMPACT

THE FIRST RESPONSES

KEY POINTS

- Critiques of "A Theory of Human Motivation" focused primarily on flaws in Abraham Maslow's methodology—the process of his research and analysis— and the ambiguity of his concept of self-actualization.*

- Having established the intellectual basis of his theory in "A Theory of Human Motivation," much of the rest of Maslow's career and his subsequent publications focused on responding to criticism of his work.

- The most important factor shaping the reception of the text was how persuasive—and self-evident—his hierarchy of needs* was.

Criticism

Critiques of Abraham Maslow's "A Theory of Human Motivation" focus primarily on his methodology and his concept of self-actualization. In terms of methodology, Maslow's article was not particularly scientific. For example, the psychiatrist Mahmoud Wahba* and the international relations scholar Lawrence Bridwell* have argued that Maslow's theory is not secure: "The theory is widely accepted, but there is little research evidence to support it."[1] For them, at its core it is "a nontestable theory." Moreover, they suggest Maslow "did not attempt to provide rigor in his writing or standard definitions of constructions," nor did he "discuss any guides for empirical verification" (evidence that can be verified by observation).[2]

The second critique is that Maslow's concept of self-actualization is somewhat ambiguous, but so too are the means by which someone can achieve it.[3] Others have suggested that self-actualization may not

> 66 Though Maslow was criticized as too soft
> scientifically by American *uber* empiricists, he shared
> their belief in measurability and data as the ultimate
> determinant of human truth. 99
>
> Edward Hoffman, "Abraham Maslow: A Biographer's Reflections"

be a basic need at all, but rather based on the "wishes of what man should be rather than what he actually is."[4] For example, people who have studied piano their whole lives become self-actualized when they become successful (in terms of making a living, providing for themselves and their family, being respected) as a pianist. But what about someone who is a brilliant lawyer or scholar but actually wants to be a professional musician? Will they ever achieve self-actualization?

Finally, several scholars have found that the basic needs do not emerge in the order that Maslow suggests.[5] As one study points out, "people in impoverished nations, with only modest control over whether their basic needs are fulfilled, can nevertheless find a measure of well-being through social relationships and other psychological needs over which they have more control."[6] For example, in an impoverished country where physiological and safety needs are not always easy to satisfy, people still manage to find love and self-esteem and even self-actualization.

Responses

Maslow was not indifferent to these challenges, and sought to clarify his theory in his next work, *Motivation and Personality* (1954). Here, he tried to shed more light on his concept of self-actualization, clarifying that every individual should be able to advance through the hierarchy of needs and eventually reach the top level. He also recognized that while everyone has the potential to achieve self-actualization, the process is often disrupted by an individual's inability to satisfy lower

needs. For example, consider a Syrian doctor who has satisfied all of their basic needs, and is well on the way toward self-actualization, but then civil war breaks out and they and their family are forced to become refugees. In effect, while they may have the love and respect of their family, they might no longer be able to satisfy their physiological and safety needs, which would inhibit their attainment of self-actualization. Maybe over time they may be able to regain these needs, perhaps taking on a lesser job as a store clerk or a taxi driver in their new country, but they will never be able to achieve self-actualization because they are no longer working toward achieving their potential.

Unfortunately, some of the more persuasive critiques of Maslow's text occurred in the late 1960s and following his sudden death in 1970. As a result, Maslow was unable to engage in further debate with those critics, like Wahba and Bridwell, who had pointed out the lack of empirical support for his theory and the ambiguity of his concept of self-actualization.

Conflict and Consensus

Maslow's efforts to refine his theory and apply it to specific circumstances, like industry, helped to advance it and today the theory remains both influential and popular, despite its inadequacies. For example, in *Motivation and Personality* he stressed that differences in cultural settings influence the way that the theory might be interpreted, but that the difference only relates to the way people *satisfy* their needs in such settings, and not to the way people *experience* them. According to Maslow, experiencing needs is a subconscious psychological phenomenon unaffected by cultural variations.

Maslow also acknowledged that a person may not fully satisfy a need, yet may still attempt to meet needs higher on the hierarchy. The degree to which a need is satisfied is based on personal perspective. For example, just because someone is hungry does not mean that they are

disinterested in safety or love. This acknowledgement shows the impact of criticism on Maslow's work, and demonstrates his recognition that needs often overlap or that human beings may pursue different needs at the same time—a position that, to some extent, weakens the idea of the hierarchical structure.

Although some aspects of Maslow's theories have been criticized—particularly the concept of self-actualization—he has nonetheless gained prominence as a leading scholar of psychology.*

Maslow's focus on human motivation and behavior is in harmony with that of later scholars in the behavioral* school of thought such as Douglas McGregor.* McGregor used "A Theory of Human Motivation" as a stepping-stone for the development of his work, *The Human Side of Enterprise* (1960). McGregor followed Maslow's call for more humanistic* orientation in the general social sciences and applied humanistic concepts in the context of management and organizational leadership. McGregor's "theory Y"* suggests that employees are also inspired by intrinsic (internal, psychological) motivations, rather than extrinsic (external) motivations such as financial incentives or the desire to avoid punishment. Theory Y's roots originate in Maslow's hierarchy of needs, as this later work reaffirms the importance of building professional relationships in harmony with employees' innate motivational needs—as outlined by Maslow.

Overall, Maslow's theory has largely been accepted among psychologists and has made a major contribution to the development of psychological science, even though elements of his work required further refinement.

NOTES

1 Mahmoud A. Wahba and Lawrence G. Bridwell, "Maslow Reconsidered: A Review of Research on the Need Hierarchy Theory," *Organizational Behavior and Human Performance* 15 (1976): 212.

2 Wahba and Bridwell, "Maslow Reconsidered," 234

3 See C. N. Cofer and M. H. Appley, *Motivation: Theory and Research* (New York: Wiley, 1964), 692.

4 Wahba and Bridwell, "Maslow Reconsidered," 233.

5 See M. R. Hagerty, "Testing Maslow's Hierarchy of Needs: National Quality-of-Life Across Time," *Social Indicators Research* 46 (1999): 249–71; J. Rauschenberger et al., "A Test of the Need Hierarchy Concept by a Markov Model of Change in Need Strength," *Administrative Science Quarterly* 25, no. 4 (1980): 654–70; and F. Wicker et al., "On Reconsidering Maslow: An Examination of the Deprivation/ Domination Proposition," *Journal of Research in Personality* 27, no. 2 (1993): 118–33.

6 Louis Tay and Ed Diener, "Needs and Subjective Well-Being Around the World," *Journal of Personality and Social Psychology* 101, no. 2 (2011): 364.

MODULE 10
THE EVOLVING DEBATE

KEY POINTS

- Maslow gradually improved the clarity of his concept of self-actualization* in the years after "A Theory of Human Motivation" was first published, also giving a broader analysis of individuals who had reached the top set of needs and achieved self-actualization.

- Since the publication of "A Theory of Human Motivation," humanistic psychology* has emerged as a major intellectual framework within the field of psychology* — though its applicability has been somewhat limited to businesses and organizations.

- Maslow's theories are still celebrated; they continue to be taught and applied in social science and business schools.

Uses and Problems

When Abraham Maslow published his article "A Theory of Human Motivation," he set out the basic framework for a new theory of why people act in the way they do. Because it was relatively short, it did not go into the theoretical detail typically found in a book. Given this, Maslow was obliged to respond to the criticism leveled at his theory, if only to reinforce and clarify what he was seeking to achieve.

Although the reputation of his humanistic* views was not tarnished, Maslow sought to clarify the ambiguity of the concept of self-actualization and the practicality of his hierarchical structure of human needs in his book *Motivation and Personality* (1954). Here Maslow not only improved the clarity of the term's definition, but gave a broader analysis of individuals who had reached this top set of needs, describing the specific characteristics that self-actualized people

> ❝ If we wish to help humans to become more fully human, we must realize not only that they try to realize themselves, but that they are also reluctant or afraid or unable to do so. Only by fully appreciating this dialectic between sickness and health can we help to tip the balance in favor of health. ❞
>
> Abraham H. Maslow, *Toward a Psychology of Being*

possess.[1] Later, in *Toward a Psychology of Being* (1962), Maslow analyzed the characteristics of people that he believed had achieved self-actualization, among them Abraham Lincoln,* Albert Einstein,* and the humanitarian Eleanor Roosevelt,* and proposed 15 characteristics that are found in the state of mind and behavior of self-actualized people. In doing so, he tried to rebut the criticisms that self-actualization is utopic (that is, perfect or ideal, often in an illusionary way) and impossible to achieve, and that the theory's application and testing were troublesome.

These developments and clarifications of his initial thoughts act as strategic guidelines for reaching the highly desirable state of self-actualization.[2] This created a consensus in the debate between the author and those who argued that his work failed to show that everyone can reach the highest levels.

Schools of Thought

Maslow's hierarchy of needs* contributed significantly to the development of the humanistic school of psychology, which focused on the inherent good of human beings. This stands in stark contrast to Sigmund Freud's* psychoanalytic* theory, founded on studies of the mentally ill. Maslow and his followers believed that a mentally healthy person occurred more commonly among the wider population and also appeared to be a better baseline for establishing a set of ideas and

theories that could be used to help treat the mentally ill. Similarly, Maslow believed that John Watson* and Ivan Pavlov's* behaviorist* approach was equally flawed, because it sought to apply to humans lessons learned from animals. As Maslow pointed out, studying rats to develop lessons for humans was misguided, because humans and rats are quite different beings. As he observed, "rats have few motivations other than physiological* ones, and since so much of the research upon motivation has been made with these animals, it is easy to carry the rat-picture over to the human being."[3]

By pointing out the fundamental flaws of the two leading schools of psychology, Maslow struck a chord among other psychologists, who had felt similar frustrations with the existing models. Before long, humanism was established as a third force in the field of psychology, with a large company of followers. In this sense, Maslow has emerged as the founder of the humanistic school of psychology.

Humanistic psychology is designed to encourage subjects to change their state of mind from having negative thoughts and reactions to one focused on self-awareness and thoughtfulness. For example, a person who has had a negative childhood, and has become obsessive about their physical appearance, would be encouraged to be self-aware of their obsessive actions and to adopt a healthy means of channeling their behavior toward achieving self-actualization, perhaps through eating healthily, being physically active, or trying meditation.

In Current Scholarship

In the decades since Maslow first proposed his theory, scholars and practitioners have continued to teach and apply the central elements of his theory to real-world situations. A theory put forward in a short article and then expanded in subsequent books has its limitations. As a result, several scholars have sought to reformulate Maslow's ideas into a more workable model, particularly in the face of new findings from researchers that work in the more scientific fields of neuroscience (the

study of the functioning of the brain), developmental biology (the study of how organisms develop into maturity), and evolutionary psychology (psychological research conducted in the light of evolutionary theory). These modern researchers found that Maslow had failed to take into consideration the organism's need to reproduce.

In 2010, the psychologist Douglas Kenrick* and his colleagues at the medical research facility known as the American National Institutes of Health published an article, "Renovating the Pyramid of Needs," that sought to reformulate Maslow's hierarchy of needs to include reproductive needs. Instead of Maslow's basic categories—physiological needs, safety, love, self-esteem, and self-actualization—Kenrick altered the list slightly to include acquiring and keeping a mate ("mate retention") and parenting, in place of Maslow's central theoretical concept of self-actualization.

Kenrick clearly agreed with Maslow on his first four categories of need, which are the same, but he was not entirely convinced that self-actualization came in the form of creative displays, like art or music. In fact, he believed that "human displays of creative and intellectual capacities are directly linked to reproductive success." He argued that "talented artists, musicians, or writers frequently show off their creative outputs to others and may receive very high levels of fame, resources, and romantic interest as a result." As an example, Kenrick pointed to how the British musician John Lennon*—and similar talented individuals—converted his actualized talents into fame, financial resources, and reproductive opportunities.[4]

NOTES

1 Mahmoud A. Wahba and Lawrence G. Bridwell, "Maslow Reconsidered: A Review of Research on the Need Hierarchy Theory," *Organizational Behavior and Human Performance* 15 (1976): 212–40.

2 Abraham H. Maslow, *Toward a Psychology of Being* (Princeton, NJ: Van Nostrand Company, 1962), 12–34.

3 Abraham H. Maslow, "A Theory of Human Motivation," *Psychological Review* 50, no. 4 (1943): 374.

4 Douglas Kenrick et al., "Renovating the Pyramid of Needs: Contemporary Extensions Built upon Ancient Foundations," *Perspectives on Psychological Science* 5, no. 3 (2010).

IMPACT AND INFLUENCE TODAY

KEY POINTS

* Abraham Maslow's theoretical framework has served as inspiration for generations of scholars—not only in the field of psychology,* but also in the sphere of contemporary management.

* While the theory of motivation is declining in importance to contemporary psychology, it has seen a boost in influence in fields such as management, strategy, and marketing.

* For organizational scientists* (people applying and extending organizational theories), Maslow's concepts can lead to higher productivity if applied to the management of corporations—higher productivity being the natural outcome of having self-motivated and ambitious employees who exercise self-control in the workplace and feel important to the enterprise's operations.

Position

The theory Abraham Maslow introduced in "A Theory of Human Motivation" revolutionized the field of psychology soon after the text's first appearance in 1943.[1] Nevertheless, it has undoubtedly lost some of its standing in the academic world as scholars have scrutinized its central tenets on the basis of new modes of analysis. Even so, Maslow continues to be recognized for having introduced the humanistic* perspective to the field of psychology.

While Maslow's ideas may no longer be central to the development of the field, they continue to be used in other spheres. In particular, Maslow's theory has revolutionized contemporary theories of the functioning of organizations, especially the way corporations are

> **❝ Maslow's pyramid of human needs, proposed in 1943, has been one of the most cognitively contagious ideas in the behavioral sciences. ❞**
>
> Douglas T. Kenrick et al., "Renovating the Pyramid of Needs"

managed and how they pay attention to employees' needs. For example, the scholar and business consultant Chris Argyris* claimed that Maslow's theories could be used to enhance the effectiveness of a business or organization. In his book *On Organizational Learning* (1978), Argyris found that there was a mismatch between the psychological needs and desires of individuals and those of formal organizations. He argued that management sciences* (a field aiming to identify, analyze, and solve problems related to the operations and efficiency of organizations) needed to acknowledge behaviorist ideas from a humanistic perspective, and that businesses needed to adopt an organizational structure designed to ensure that employees were able to achieve their basic needs and eventually self-actualization.*[2]

Interaction

Within the business context, organizations drawing on the principles of Maslow's hierarchy of needs enjoy an increase in output and higher value creation* (the process of creating value through products and services). The evolution of the theory of motivation, then, should not only be viewed in terms of its declining importance to contemporary psychology, but through the prism of its increased applicability in the fields of management, strategy, and marketing.

Despite its continued relevance to business, the cultural relevance of Maslow's theory remains highly questionable today. Critics, like the Chinese biologist Y. Yu* and the psychologist Kuo-Shu Yang,* have claimed that its validity does not hold up in diverse cultural settings. Writing in in the early 1990s, Yu sought to replace Maslow's

hierarchy of needs* with a new Y-shaped model, with physiological* and safety needs at the bottom, then separating into two axes. The first axis followed in the traditional direction toward self-actualization that Maslow originally put forward (love, self-esteem, and self-fulfillment), while the second axis focused on the direction of life, which included sexual, romantic, childbearing, child-rearing and child-educating needs.[3]

In 2003, Yang sought to modify Yu's structure slightly by combining, first, sexual and romantic needs, and second, child-rearing and child-educating needs. He argued that there was no real way to distinguish which of these needs is more important.[4] For example, how are sexual needs more or less important than romantic needs? What about a couple that chooses to wait until marriage before engaging in any sexual conduct, even kissing? Or a couple who do not want to have children? Surely their romantic connection is more important than their sexual or reproductive connection.

While these efforts at revising Maslow's theory reflect a consensus on the importance of physiological and safety needs, where the hierarchy goes from there is still subject to debate.

The Continuing Debate
Among other fields, Maslow's theory of human motivation was crucial to the evolution of organizational management* where businesses that seek to encourage the self-actualization of their employees tend to experience higher productivity. By making business managers aware of universal sets of needs and desires, Maslow not only remains relevant today, but can also be seen as an innovator who instigated change in contemporary governance methods and organizational theories. The point of consensus between past and present is the shared understanding that, within a proper nurturing environment, people will be motivated to improve their potential and contribute more effectively to meet the objectives of a business or organization.

After a flurry of academic responses in the 1960s and 1970s, and

recent efforts to adapt his work in the face of modern advances, debates about the applicability of Maslow's theory have subsided. Howecer, if "A Theory of Human Motivation" is no longer central to the principal intellectual debates in the field of psychology and business management, it is not because it is without relevance but rather because its contribution and legitimacy are seldom questioned.

In response to Yu and Yang's efforts to reformulate Maslow's linear hierarchical model into a Y-shaped model, the psychologist Douglas Kenrick and his colleagues at the National Institutes of Health revised Maslow's model in the 2010 article "Renovating the Pyramid of Needs." Like Yu and Yang, Kenrick believed that self-actualization was somewhat ambiguous and replaced it with three categories: mate acquisition, mate retention (the need to retain a partner), and parenting. This approach factors in the sexual aspects of the earlier studies, while offering a more simplified end-goal of parenting.[5]

Over time, Maslow's theories have ridden out the criticisms and fueled considerable intellectual debate within the fields of organizational management and psychology. The limitations of the work should not be disregarded, but acknowledged and taken into consideration when its theories are applied. From a contemporary perspective, it is clear that the scope of its application is beyond question, despite criticism of the hierarchical structure and its methodology. Maslow's theories made a lasting impact on people management within an organizational setting, ensuring that personal and social needs and desires no longer presented a distraction.

NOTES

1 Edward Hoffman, "Abraham Maslow: A Biographer's Reflections," *Journal of Humanistic Psychology* 48, no. 4 (2008): 439–43.

2 Chris Argyris, *On Organizational Learning,* 2nd edn (Oxford: Blackwell, 1999), 40–5.

3 Y. Yu, *The Y-shaped Structure: The Nature and Nurture of Human Nature* (Guangzhou: Huachang, 1992).

4 Kuo-Shu Yang, "Beyond Maslow's Culture-Bound Linear Theory: A Preliminary Statement of the Double-Y Model of Basic Human Needs," *Nebraska Symposium on Motivation* 49 (Lincoln: University of Nebraska Press, 2001): 186–7.

5 Douglas Kenrick et al., "Renovating the Pyramid of Needs: Contemporary Extensions Built upon Ancient Foundations," *Perspectives on Psychological Science* 5, no. 3 (2010).

MODULE 12
WHERE NEXT?

KEY POINTS

- Future direction for the development of Maslow's core motivational ideas includes the creation of frameworks for the practical application of the ideas within organizational management.*

- Future frameworks for the practical application of Maslow's theories should include his recommendations for satisfying employees' physiological,* safety, social, esteem, and self-actualization* needs if their full potential is to be realized.

- We can be confident that Maslow's legacy in the field of human motivation is assured.

Potential

By revealing what drives human motivation, Abraham Maslow's "A Theory of Human Motivation" offered a tool for establishing a mutually beneficial relationship between managers and employees that was based on more than monetary incentives and social dominance. Unfortunately, despite the availability of this model for creating and preserving a productive cooperation between these two—often conflicting—parties, it is still common to find formal organizations that have not applied Maslow's humanistic* recommendations. It could be argued, then, that the full potential of motivation theory has not yet been realized in the field of business, and greater efforts should be made to communicate these academic theories and their value in order to create more productive business environments. Applying Maslow's humanistic recommendations within a broader number and range of organizations is a viable next step.

Research on formal organizational structures and effective forms

> 66 We believe it useful to examine basic human motives at three different levels of analysis often conflated in Maslow's work: (a) their ultimate evolutionary function, (b) their developmental sequencing, and (c) their cognitive priority as triggered by proximate inputs. 99
>
> Douglas T. Kenrick et al., "Renovating the Pyramid of Needs"

of governance has now emerged as an important area in which Maslow's theory of human motivation can be applied. Maslow's followers have used his framework of human needs to explore how organizations can become more harmonious places in which both the needs of the individual and the demands of managers for productivity are met.[1] However, there remains considerable room for improvement in both business and nonbusiness organizations.

Future Directions

Even today, many formal organizations do not succeed in implementing Maslow's humanistic recommendations. For this next step to be realized, managers should be encouraged to satisfy their employees' physiological needs through the provision of reasonable salaries, breaks, and refreshment; their safety needs by offering job security, safe working conditions, and health and retirement benefits; their social needs by fostering a team environment that includes team-building and other social activities, like office parties; their esteem needs through the establishment of a reward scheme designed to motivate workers not only with payment but social appreciation; and finally, their self-actualization needs by encouraging creativity and the freedom to experiment with new ideas, by challenging workers with more demanding projects, and by offering advanced training opportunities for those who wish to pursue higher goals.

While Maslow's theory may not be as applicable today to the field

of clinical* psychology as it once was (that is, it is no longer used in the treatment of psychological* conditions), there is little question that its applicability to the business world is gaining in popularity. Major technological companies, among them the US giants Google and Apple, appear to have applied this model by offering their employees outstanding benefit packages, relaxing work environments, and encouragements towards creative thinking to solve complex problems. It is reasonable to assume that the future direction for development of Maslow's core motivational ideas includes the creation of frameworks within organizational management designed to facilitate the realization of employees' full potential. This would constitute a concrete legacy, as opposed to the development of purely theoretical underpinnings that could be of debatable practicality.

Summary

"A Theory of Human Motivation" has had a lasting influence within the field of psychology, having established psychological humanism as a third force of psychology after Sigmund Freud's* psychoanalysis*and John Watson* and Ivan Pavlov's* behaviorism.* Beyond the field of psychology, Maslow's theory of human motivation has been influential in fields ranging from the management of businesses to strategic military studies aimed at defeating an enemy through the deprivation of basic needs. The success of this text is reflected in the fact that it continues to be taught in schools of business, sociology,* and psychology, creating a general familiarity with Maslow's hierarchy of needs.* Even fields as far removed from psychology and business as international development* (the process of increasing a developing nation's prosperity and its citizens' standard of living) use his hierarchy of needs when developing programs designed to ensure that people in desperate situations are not deprived of their basic physiological needs, like food and water. This hierarchy continues to be regarded as significant, not only by the general public but also by managers and academics.

The text's most far-reaching impact today has been its impact on how organizations and businesses are structured. Managers graduating from prestigious business schools are aware of human motivation theory; they form a professional body of people who believe in Maslow's concepts and are ready to implement them in the value creation* process. This awareness has allowed management professionals to reject the top-down approach rooted in Freud's psychoanalysis and replace it with a more sustainable, humanistic relationship between organizations and their employees, according to which respect for individuals' human needs, ambitions, and desires serves as a way to reach organizational goals.[2]

No matter whether they agree fully or partially with Maslow's propositions, scholars appear certain of the benefits that stem from furthering Maslow's research into human motivation.

NOTES

1 Douglas Kenrick et al., "Renovating the Pyramid of Needs: Contemporary Extensions Built upon Ancient Foundations," *Perspectives on Psychological Science* 5, no. 3 (2010): 292–314.

2 Abraham H. Maslow, "A Theory of Human Motivation," *Psychological Review* 50, no. 4 (1943): 370–96.

GLOSSARY

GLOSSARY OF TERMS

Animalism: behavior that resembles the instinctive characteristics of animals.

Anti-Semitism: prejudice against Jews.

Behaviorism: the theory that behaviors can be measured, trained, and changed, and that psychological disorders can be treated by addressing behavior. The behaviorist school was established with the publication of John Watson's work "Psychology as the Behaviorist Views It" (1913).

Cardinal traits: traits or characteristics that dominate a person's character (for example, obsession with success).

Central traits: traits or characteristics that form the core of a person's personality (for example, honesty, selfishness, intelligence).

Clinical psychology: the branch of psychology that diagnoses and treats mental and behavioral problems by therapeutic means.

Conditioning: the process by which a person or animal is exposed to a stimulus that brings about a certain result.

Conscious motivation: awareness of the desire to conduct an activity.

Enlightenment: also known as "the Age of Reason," this was a Western intellectual movement of the seventeenth and eighteenth centuries that questioned tradition and religious belief while advancing knowledge of the world through scientific method.

Hierarchy of needs: a theory in the field of psychology that holds that humans are motivated by their need to satisfy a series of hierarchical needs, starting with essential needs (that is, physiological and safety needs) and proceeding to those of love, self-esteem, and self-actualization after the essential needs are relatively satisfied.

Humanism: an approach to psychology that emphasizes the value of human beings, individually and collectively, by adopting rational and empirical evidence (evidence verifiable by observation) rather than relying on previously established psychological doctrines.

Humanistic psychology: a field of psychology that holds that humans are inherently good beings. It is considered the third force of psychology, having successfully challenged psychoanalysis and behaviorist paradigms (intellectual frameworks).

Human personality theory: a branch of psychology that studies patterns of human nature, with particular emphasis on individuals' differences and similarities.

Human potential: the belief that humans are inherently good, with largely untapped abilities and capacities.

Human potential movement: a group of scholars who believed that humans were inherently good beings, with largely untapped potential. The movement originated in the 1960s.

International development: the effort to provide a higher standard of life for the citizens of poorer, less-developed nations.

Management science/studies: the field that aims to identify, analyze, and solve problems related to the operations and efficiency of organizations.

Metamotivation: a term used to describe people's motivation to achieve something beyond their basic needs, to become "self-actualized."

Metaneeds: a term used to describe human needs that go beyond basic physiological requirements for food, shelter, and so on.

Nazi Germany: the period from 1933 to 1945 when Germany was under the control of the extreme right wing, nationalist Nazi Party and its leader Adolf Hitler.

Organizational management: the process of governing organizations in a way that certain strategic objectives can be achieved. It typically involves the acts of exercising control, leadership, planning, and strategizing.

Organizational scientists: the people applying and extending organizational theories.

Pearl Harbor: a US naval base in the territory of Hawaii.

Physiological needs: the bodily requirements that need to be satisfied for the normal functioning of living organisms.

Positivism: a perspective in the philosophy of science holding that information must be obtained by sensory experience (what is seen and heard in the real world). Laws are derived from these observations and tested through experimentation.

Psychoanalysis: a theoretical and therapeutic approach to understanding and treating the unconscious mind by way of dialogue between the patient and a therapist. The concept was introduced by

the Austrian neurologist Sigmund Freud.

Psychology: the science that explores the human mind and its behavior.

Psychopathology: the field that explores people's mental health, its features, and related disorders.

Psychopathy: the mental disorder in which an individual displays amoral and antisocial behavior.

Psychotherapy: the attempt to address mental disorders in patients by pursuing verbal, psychological means rather than medical interventions.

Secondary traits: personal traits or characteristics that only become present during certain circumstances (for example, cowardice or pickiness).

Self-actualization: a term first coined by the German psychiatrist Kurt Goldstein, who used it to describe people's drive to realize their full potential, unleash creativity, pursue knowledge, and give back to society.

Social science: the body of work that explores human society and human relationships.

Socioeconomic: relating to the interaction of economic and social factors.

Sociology: the study of social development, social behavior, social organizations, social networks, and social institutions.

Sustainable development goals: a set of development goals adopted by the United Nations in 2015 aimed at reducing poverty.

Theory Y: a theory developed by the psychologist and management scholar Douglas McGregor in his work *The Human Side of Enterprise* (1960). The theory suggests that people are self-motivated and, therefore, do not need strict control—a factor that is considered to lead to counterproductivity.

Total war: a concept used to describe a state of war when all of the resources of a nation are directed toward fighting the conflict.

Trait theory: an approach to exploring human personality by measuring patterns of thoughts and behavior (that is, traits).

Value creation: the process of creating value through products and services.

World War II (1939–45): a global conflict fought between the Axis Powers (Germany, Italy, and Japan) and the victorious Allied Powers (United Kingdom and its dominions and colonies, the former Soviet Union, and the United States).

PEOPLE MENTIONED IN THE TEXT

Alfred Adler (1870–1937) was an Austrian psychologist and founder of the school of individual psychology, according to which a patient's whole environment should be taken into account.

Gordon Allport (1897–1967) was an American psychologist focusing on the personality. He is regarded as one of the founding fathers of personality psychology.

Chris Argyris (1923–2013) was an American business theorist and a professor emeritus at Harvard University. He is best known for his seminal work in the area of "learning organizations."

Aristotle (384–322 B.C.E.) was a Greek philosopher and founding figure of Western philosophy. He wrote on ethics, politics, aesthetics, logic, metaphysics (the branch of philosophy dealing with fundamental matters of existence), and science.

Ruth Benedict (1887–1948) was an influential American anthropologist and president of the American Anthropological Association. She is considered a pioneer in the field of cultural anthropology.

Lawrence Bridwell is a professor of international relations at Pace University.

Albert Einstein (1879–1955) was a German-born American physicist, famous for his theory of relativity and his role in the development of the theoretical foundations of nuclear science and weaponry.

Sigmund Freud (1856–1939) was an Austrian neurologist who
pioneered psychoanalysis, a method for understanding the role of the
unconscious mind in the composition of the human personality and
behavior. He is regarded as one of the world's most original and
influential thinkers.

Erich Fromm (1900–80) was a German social psychologist who
identified the inconsistency of Freudian theory before and after World
War II. He criticized Freud and his followers for never addressing
these inconsistencies.

Kurt Goldstein (1878–1965) was a German psychiatrist, best
known for his book *The Organism* (1939) and his holistic theory
("holistic" here referring to the assumption that a phenomenon can
only be explained by considering its various components to be
essentially integrated).

Hippocrates (460–370 B.C.E.) was an ancient Greek physician. He
is largely considered to be the founder of medicine as a field of study.

Edward Hoffman is a New York-based psychologist and biographer
of Abraham Maslow.

Karen Horney (1885–1952) was a German psychoanalyst and
founder of feminist psychology. She famously challenged Freud's
position that differences in psychology between genders are based on
biological factors, stating instead that they are a symptom of how
society views men and women.

Immanuel Kant (1724–1804) was a German philosopher. He is
notable, among other things, for his defense of the idea that all people
are worthy of equal consideration and respect, based on the idea that

one should act as though one's actions were the universal law (the "categorical imperative").

Douglas Kenrick (b. 1948) is a professor of psychology at Arizona State University who has sought to synthesize scientific research with psychological theory.

John Lennon (1940–80) was a British musician famous for his work with The Beatles, a musical group widely considered one of the most influential bands of all time.

Abraham Lincoln (1809–65) was the 16th president of the United States, notable for abolishing slavery and winning the American Civil War. He was assassinated by John Wilkes Booth while attending a play at the Ford Theatre in Washington, DC.

Douglas McGregor (1906–64) was a psychologist and management professor at the MIT Sloan School of Management. His seminal work *The Human Side of Enterprise* (1960) had a significant influence on education practices.

Ivan Pavlov (1849–1936) was a Russian psychologist. He is famous for his experiments with dogs, through which he developed his belief that humans and animals can be conditioned to produce specific responses. His research led to the development of the behaviorist school of psychology.

Plato (circa 428–circa 348 B.C.E.) was a Greek philosopher who founded the Academy in Athens, the first Western institution of higher learning.

Carl Rogers (1902–87) was an influential American psychologist,

honored for his research on humanism with the American Psychological Association Award for Distinguished Scientific Contributions.

Eleanor Roosevelt (1884–1962) was the wife of the 32nd president of the United States, Franklin D. Roosevelt. A notable humanist, she played an integral role in the drafting of the United Nations' Universal Declaration of Human Rights.

Edward L. Thorndike (1874–1949) was an American psychologist. His major contributions to psychology are related to the fields of animal behavior and the learning process. His legacy includes the theory of connectionism, and his scholarly input laid the foundations of modern educational psychology.

Sun Tzu (circa 544–496 B.C.E.) was a Chinese military general and strategist, noted for his guide to military strategy, *The Art of War*.

Mahmoud Wahba is a clinical psychiatrist based in Kansas City in the United States.

John Watson (1878–1958) was an American psychologist and founder of the psychological school of behaviorism.

Max Wertheimer (1880–1943) was a psychologist and one of the founders of the Gestalt approach. The vision of this school of thought is expressed by Wolfgang Kohler's quote, "The whole is greater than the sum of its parts."

Wilhelm Wundt (1832–1920) was a German psychologist, best known for establishing psychology as a discipline of its own, separate from philosophy.

Kuo–Shu Yang is a scholar in the field of psychology. He has served as the president of the Chinese Psychological Association.

Y. Yu is a scholar in the field of biology who proposed the Y model of basic human needs in 1992.

WORKS CITED

WORKS CITED

Allport, Gordon. *Personality: A Psychological Interpretation.* New York: Henry Holt & Co, 1937.

Argyris, Chris. *On Organizational Learning.* Second edition. Oxford: Blackwell, 1999.

Bellott, F. K., and F. D. Tutor. "A Challenge to the Conventional Wisdom of Herzberg and Maslow Theories." Presentation at the Annual Meeting of the Mid-South Educational Research Association, New Orleans, 1990.

Cofer, C. N., and M. H. Appley. *Motivation: Theory and Research.* New York: Wiley, 1964.

Goldstein, Kurt. *The Organism: A Holistic Approach to Biology Derived From Pathological Data in Man.* Cambridge, MA: Zone Books/MIT Press, 2000.

Haggbloom, Steven J., Renee Warnick, Jason E. Warnick, Vinessa K. Jones, Gary L. Yarbrough, Tenea M. Russell, Chris M. Borecky, Reagan McGahhey, John L. Powell III, Jamie Beavers, and Emmanuelle Monte. "The 100 Most Eminent Psychologists of the 20th Century." *Review of General Psychology* 6, no. 2 (2002): 139–52. doi:10.1037/1089-2680.6.2.139.

Herzberg, Frederick, Bernard Mausner, and Barbara Bloch Snyderman. *The Motivation to Work.* New Brunswick, NJ: Transaction Publishers, 1993.

Hoffman, Edward. *The Right to be Human: A Biography of Abraham Maslow.* Second edition. New York: McGraw-Hill, 1999.

— — —. "Abraham Maslow's Life and Unfinished Legacy." *Japanese Journal of Administrative Science* 17, no.3 (2004): 133.

— — —. "Abraham Maslow: A Biographer's Reflections." *Journal of Humanistic Psychology* 48, no. 4 (2008): 439–43.

Kenrick, Douglas, Vladas Griskevicius, Steven Neuberg, and Mark Schaller. "Renovating the Pyramid of Needs: Contemporary Extensions Built Upon Ancient Foundations." *Perspectives on Psychological Science* 5, no. 3 (2010): 292–314.

Maslow, Abraham H. A Theory of Human Motivation." *Psychological Review* 50, no. 4 (1943): 370–96.

— — —. *Toward a Psychology of Being.* New York: Van Nostrand, 1962.

— — —. "*Eupsychian Management: A Journal.* New York: R.D. Irwin, 1965.

— — —. *Motivation and Personality*. Revised by Robert Frager. London: Harper & Row, 1987.

— — —. *Religion, Values and Peak Experiences*. New York: Penguin Arkana, 1994.

McGregor, Douglas. *The Human Side of Enterprise*. Annotated edition. New York: McGraw-Hill, 2006.

Tzu, Sun. *The Art of War*. Translated by Lionel Giles. Accessed October 13, 2015. http://classics.mit.edu/Tzu/artwar.html.

United Nations. "Sustainable Development Goals," September 25, 2015. Accessed January 19, 2015. https://sustainabledevelopment.un.org/post2015/summit.

Wahba, Mahmoud A., and Lawrence G. Bridwell. "Maslow Reconsidered: A Review of Research on the Need Hierarchy Theory." *Organizational Behavior and Human Performance* 15 (1976): 212–40.

Watson, John B. "Psychology as the Behaviorist Views It." *Psychological Review* 20 (1913): 158–77.

— — —. *Behaviorism.* Seventh edition. New York: Transaction Publishers, 1998.

Watson, John B., and Rosalie Rayner Watson. "Studies in Infant Psychology." *Scientific Monthly* 13, no. 6 (1921): 493–515.

Yang, Kuo-Shu. "Beyond Maslow's Culture-Bound Linear Theory: A Preliminary Statement of the Double-Y Model of Basic Human Needs." *Nebraska Symposium on Motivation* 49 (Lincoln: University of Nebraska Press, 2001): 186–7.

Yu, Y. *The Y-shaped Structure: The Nature and Nurture of Human Nature.* Guangzhou: Huachang, 1992.

THE MACAT LIBRARY
BY DISCIPLINE

The Macat Library By Discipline

AFRICANA STUDIES

Chinua Achebe's *An Image of Africa: Racism in Conrad's Heart of Darkness*
W. E. B. Du Bois's *The Souls of Black Folk*
Zora Neale Huston's *Characteristics of Negro Expression*
Martin Luther King Jr's *Why We Can't Wait*
Toni Morrison's *Playing in the Dark: Whiteness in the American Literary Imagination*

ANTHROPOLOGY

Arjun Appadurai's *Modernity at Large: Cultural Dimensions of Globalisation*
Philippe Ariès's *Centuries of Childhood*
Franz Boas's *Race, Language and Culture*
Kim Chan & Renée Mauborgne's *Blue Ocean Strategy*
Jared Diamond's *Guns, Germs & Steel: the Fate of Human Societies*
Jared Diamond's *Collapse: How Societies Choose to Fail or Survive*
E. E. Evans-Pritchard's *Witchcraft, Oracles and Magic Among the Azande*
James Ferguson's *The Anti-Politics Machine*
Clifford Geertz's *The Interpretation of Cultures*
David Graeber's *Debt: the First 5000 Years*
Karen Ho's *Liquidated: An Ethnography of Wall Street*
Geert Hofstede's *Culture's Consequences: Comparing Values, Behaviors, Institutes and Organizations across Nations*
Claude Lévi-Strauss's *Structural Anthropology*
Jay Macleod's *Ain't No Makin' It: Aspirations and Attainment in a Low-Income Neighborhood*
Saba Mahmood's *The Politics of Piety: The Islamic Revival and the Feminist Subject*
Marcel Mauss's *The Gift*

BUSINESS

Jean Lave & Etienne Wenger's *Situated Learning*
Theodore Levitt's *Marketing Myopia*
Burton G. Malkiel's *A Random Walk Down Wall Street*
Douglas McGregor's *The Human Side of Enterprise*
Michael Porter's *Competitive Strategy: Creating and Sustaining Superior Performance*
John Kotter's *Leading Change*
C. K. Prahalad & Gary Hamel's *The Core Competence of the Corporation*

CRIMINOLOGY

Michelle Alexander's *The New Jim Crow: Mass Incarceration in the Age of Colorblindness*
Michael R. Gottfredson & Travis Hirschi's *A General Theory of Crime*
Richard Herrnstein & Charles A. Murray's *The Bell Curve: Intelligence and Class Structure in American Life*
Elizabeth Loftus's *Eyewitness Testimony*
Jay Macleod's *Ain't No Makin' It: Aspirations and Attainment in a Low-Income Neighborhood*
Philip Zimbardo's *The Lucifer Effect*

ECONOMICS

Janet Abu-Lughod's *Before European Hegemony*
Ha-Joon Chang's *Kicking Away the Ladder*
David Brion Davis's *The Problem of Slavery in the Age of Revolution*
Milton Friedman's *The Role of Monetary Policy*
Milton Friedman's *Capitalism and Freedom*
David Graeber's *Debt: the First 5000 Years*
Friedrich Hayek's *The Road to Serfdom*
Karen Ho's *Liquidated: An Ethnography of Wall Street*

John Maynard Keynes's *The General Theory of Employment, Interest and Money*
Charles P. Kindleberger's *Manias, Panics and Crashes*
Robert Lucas's *Why Doesn't Capital Flow from Rich to Poor Countries?*
Burton G. Malkiel's *A Random Walk Down Wall Street*
Thomas Robert Malthus's *An Essay on the Principle of Population*
Karl Marx's *Capital*
Thomas Piketty's *Capital in the Twenty-First Century*
Amartya Sen's *Development as Freedom*
Adam Smith's *The Wealth of Nations*
Nassim Nicholas Taleb's *The Black Swan: The Impact of the Highly Improbable*
Amos Tversky's & Daniel Kahneman's *Judgment under Uncertainty: Heuristics and Biases*
Mahbub Ul Haq's *Reflections on Human Development*
Max Weber's *The Protestant Ethic and the Spirit of Capitalism*

FEMINISM AND GENDER STUDIES

Judith Butler's *Gender Trouble*
Simone De Beauvoir's *The Second Sex*
Michel Foucault's *History of Sexuality*
Betty Friedan's *The Feminine Mystique*
Saba Mahmood's *The Politics of Piety: The Islamic Revival and the Feminist Subject*
Joan Wallach Scott's *Gender and the Politics of History*
Mary Wollstonecraft's *A Vindication of the Rights of Women*
Virginia Woolf's *A Room of One's Own*

GEOGRAPHY

The Brundtland Report's *Our Common Future*
Rachel Carson's *Silent Spring*
Charles Darwin's *On the Origin of Species*
James Ferguson's *The Anti-Politics Machine*
Jane Jacobs's *The Death and Life of Great American Cities*
James Lovelock's *Gaia: A New Look at Life on Earth*
Amartya Sen's *Development as Freedom*
Mathis Wackernagel & William Rees's *Our Ecological Footprint*

HISTORY

Janet Abu-Lughod's *Before European Hegemony*
Benedict Anderson's *Imagined Communities*
Bernard Bailyn's *The Ideological Origins of the American Revolution*
Hanna Batatu's *The Old Social Classes And The Revolutionary Movements Of Iraq*
Christopher Browning's *Ordinary Men: Reserve Police Batallion 101 and the Final Solution in Poland*
Edmund Burke's *Reflections on the Revolution in France*
William Cronon's *Nature's Metropolis: Chicago And The Great West*
Alfred W. Crosby's *The Columbian Exchange*
Hamid Dabashi's *Iran: A People Interrupted*
David Brion Davis's *The Problem of Slavery in the Age of Revolution*
Nathalie Zemon Davis's *The Return of Martin Guerre*
Jared Diamond's *Guns, Germs & Steel: the Fate of Human Societies*
Frank Dikotter's *Mao's Great Famine*
John W Dower's *War Without Mercy: Race And Power In The Pacific War*
W. E. B. Du Bois's *The Souls of Black Folk*
Richard J. Evans's *In Defence of History*
Lucien Febvre's *The Problem of Unbelief in the 16th Century*
Sheila Fitzpatrick's *Everyday Stalinism*

Eric Foner's *Reconstruction: America's Unfinished Revolution, 1863-1877*
Michel Foucault's *Discipline and Punish*
Michel Foucault's *History of Sexuality*
Francis Fukuyama's *The End of History and the Last Man*
John Lewis Gaddis's *We Now Know: Rethinking Cold War History*
Ernest Gellner's *Nations and Nationalism*
Eugene Genovese's *Roll, Jordan, Roll: The World the Slaves Made*
Carlo Ginzburg's *The Night Battles*
Daniel Goldhagen's *Hitler's Willing Executioners*
Jack Goldstone's *Revolution and Rebellion in the Early Modern World*
Antonio Gramsci's *The Prison Notebooks*
Alexander Hamilton, John Jay & James Madison's *The Federalist Papers*
Christopher Hill's *The World Turned Upside Down*
Carole Hillenbrand's *The Crusades: Islamic Perspectives*
Thomas Hobbes's *Leviathan*
Eric Hobsbawm's *The Age Of Revolution*
John A. Hobson's *Imperialism: A Study*
Albert Hourani's *History of the Arab Peoples*
Samuel P. Huntington's *The Clash of Civilizations and the Remaking of World Order*
C. L. R. James's *The Black Jacobins*
Tony Judt's *Postwar: A History of Europe Since 1945*
Ernst Kantorowicz's *The King's Two Bodies: A Study in Medieval Political Theology*
Paul Kennedy's *The Rise and Fall of the Great Powers*
Ian Kershaw's *The "Hitler Myth": Image and Reality in the Third Reich*
John Maynard Keynes's *The General Theory of Employment, Interest and Money*
Charles P. Kindleberger's *Manias, Panics and Crashes*
Martin Luther King Jr's *Why We Can't Wait*
Henry Kissinger's *World Order: Reflections on the Character of Nations and the Course of History*
Thomas Kuhn's *The Structure of Scientific Revolutions*
Georges Lefebvre's *The Coming of the French Revolution*
John Locke's *Two Treatises of Government*
Niccolò Machiavelli's *The Prince*
Thomas Robert Malthus's *An Essay on the Principle of Population*
Mahmood Mamdani's *Citizen and Subject: Contemporary Africa And The Legacy Of Late Colonialism*
Karl Marx's *Capital*
Stanley Milgram's *Obedience to Authority*
John Stuart Mill's *On Liberty*
Thomas Paine's *Common Sense*
Thomas Paine's *Rights of Man*
Geoffrey Parker's *Global Crisis: War, Climate Change and Catastrophe in the Seventeenth Century*
Jonathan Riley-Smith's *The First Crusade and the Idea of Crusading*
Jean-Jacques Rousseau's *The Social Contract*
Joan Wallach Scott's *Gender and the Politics of History*
Theda Skocpol's *States and Social Revolutions*
Adam Smith's *The Wealth of Nations*
Timothy Snyder's *Bloodlands: Europe Between Hitler and Stalin*
Sun Tzu's *The Art of War*
Keith Thomas's *Religion and the Decline of Magic*
Thucydides's *The History of the Peloponnesian War*
Frederick Jackson Turner's *The Significance of the Frontier in American History*
Odd Arne Westad's *The Global Cold War: Third World Interventions And The Making Of Our Times*

The Macat Library By Discipline

LITERATURE

Chinua Achebe's *An Image of Africa: Racism in Conrad's Heart of Darkness*
Roland Barthes's *Mythologies*
Homi K. Bhabha's *The Location of Culture*
Judith Butler's *Gender Trouble*
Simone De Beauvoir's *The Second Sex*
Ferdinand De Saussure's *Course in General Linguistics*
T. S. Eliot's *The Sacred Wood: Essays on Poetry and Criticism*
Zora Neale Huston's *Characteristics of Negro Expression*
Toni Morrison's *Playing in the Dark: Whiteness in the American Literary Imagination*
Edward Said's *Orientalism*
Gayatri Chakravorty Spivak's *Can the Subaltern Speak?*
Mary Wollstonecraft's *A Vindication of the Rights of Women*
Virginia Woolf's *A Room of One's Own*

PHILOSOPHY

Elizabeth Anscombe's *Modern Moral Philosophy*
Hannah Arendt's *The Human Condition*
Aristotle's *Metaphysics*
Aristotle's *Nicomachean Ethics*
Edmund Gettier's *Is Justified True Belief Knowledge?*
Georg Wilhelm Friedrich Hegel's *Phenomenology of Spirit*
David Hume's *Dialogues Concerning Natural Religion*
David Hume's *The Enquiry for Human Understanding*
Immanuel Kant's *Religion within the Boundaries of Mere Reason*
Immanuel Kant's *Critique of Pure Reason*
Søren Kierkegaard's *The Sickness Unto Death*
Søren Kierkegaard's *Fear and Trembling*
C. S. Lewis's *The Abolition of Man*
Alasdair MacIntyre's *After Virtue*
Marcus Aurelius's *Meditations*
Friedrich Nietzsche's *On the Genealogy of Morality*
Friedrich Nietzsche's *Beyond Good and Evil*
Plato's *Republic*
Plato's *Symposium*
Jean-Jacques Rousseau's *The Social Contract*
Gilbert Ryle's *The Concept of Mind*
Baruch Spinoza's *Ethics*
Sun Tzu's *The Art of War*
Ludwig Wittgenstein's *Philosophical Investigations*

POLITICS

Benedict Anderson's *Imagined Communities*
Aristotle's *Politics*
Bernard Bailyn's *The Ideological Origins of the American Revolution*
Edmund Burke's *Reflections on the Revolution in France*
John C. Calhoun's *A Disquisition on Government*
Ha-Joon Chang's *Kicking Away the Ladder*
Hamid Dabashi's *Iran: A People Interrupted*
Hamid Dabashi's *Theology of Discontent: The Ideological Foundation of the Islamic Revolution in Iran*
Robert Dahl's *Democracy and its Critics*
Robert Dahl's *Who Governs?*
David Brion Davis's *The Problem of Slavery in the Age of Revolution*

Alexis De Tocqueville's *Democracy in America*
James Ferguson's *The Anti-Politics Machine*
Frank Dikotter's *Mao's Great Famine*
Sheila Fitzpatrick's *Everyday Stalinism*
Eric Foner's *Reconstruction: America's Unfinished Revolution, 1863-1877*
Milton Friedman's *Capitalism and Freedom*
Francis Fukuyama's *The End of History and the Last Man*
John Lewis Gaddis's *We Now Know: Rethinking Cold War History*
Ernest Gellner's *Nations and Nationalism*
David Graeber's *Debt: the First 5000 Years*
Antonio Gramsci's *The Prison Notebooks*
Alexander Hamilton, John Jay & James Madison's *The Federalist Papers*
Friedrich Hayek's *The Road to Serfdom*
Christopher Hill's *The World Turned Upside Down*
Thomas Hobbes's *Leviathan*
John A. Hobson's *Imperialism: A Study*
Samuel P. Huntington's *The Clash of Civilizations and the Remaking of World Order*
Tony Judt's *Postwar: A History of Europe Since 1945*
David C. Kang's *China Rising: Peace, Power and Order in East Asia*
Paul Kennedy's *The Rise and Fall of Great Powers*
Robert Keohane's *After Hegemony*
Martin Luther King Jr.'s *Why We Can't Wait*
Henry Kissinger's *World Order: Reflections on the Character of Nations and the Course of History*
John Locke's *Two Treatises of Government*
Niccolò Machiavelli's *The Prince*
Thomas Robert Malthus's *An Essay on the Principle of Population*
Mahmood Mamdani's *Citizen and Subject: Contemporary Africa And The Legacy Of Late Colonialism*
Karl Marx's *Capital*
John Stuart Mill's *On Liberty*
John Stuart Mill's *Utilitarianism*
Hans Morgenthau's *Politics Among Nations*
Thomas Paine's *Common Sense*
Thomas Paine's *Rights of Man*
Thomas Piketty's *Capital in the Twenty-First Century*
Robert D. Putman's *Bowling Alone*
John Rawls's *Theory of Justice*
Jean-Jacques Rousseau's *The Social Contract*
Theda Skocpol's *States and Social Revolutions*
Adam Smith's *The Wealth of Nations*
Sun Tzu's *The Art of War*
Henry David Thoreau's *Civil Disobedience*
Thucydides's *The History of the Peloponnesian War*
Kenneth Waltz's *Theory of International Politics*
Max Weber's *Politics as a Vocation*
Odd Arne Westad's *The Global Cold War: Third World Interventions And The Making Of Our Times*

POSTCOLONIAL STUDIES

Roland Barthes's *Mythologies*
Frantz Fanon's *Black Skin, White Masks*
Homi K. Bhabha's *The Location of Culture*
Gustavo Gutiérrez's *A Theology of Liberation*
Edward Said's *Orientalism*
Gayatri Chakravorty Spivak's *Can the Subaltern Speak?*

PSYCHOLOGY

Gordon Allport's *The Nature of Prejudice*
Alan Baddeley & Graham Hitch's *Aggression: A Social Learning Analysis*
Albert Bandura's *Aggression: A Social Learning Analysis*
Leon Festinger's *A Theory of Cognitive Dissonance*
Sigmund Freud's *The Interpretation of Dreams*
Betty Friedan's *The Feminine Mystique*
Michael R. Gottfredson & Travis Hirschi's *A General Theory of Crime*
Eric Hoffer's *The True Believer: Thoughts on the Nature of Mass Movements*
William James's *Principles of Psychology*
Elizabeth Loftus's *Eyewitness Testimony*
A. H. Maslow's *A Theory of Human Motivation*
Stanley Milgram's *Obedience to Authority*
Steven Pinker's *The Better Angels of Our Nature*
Oliver Sacks's *The Man Who Mistook His Wife For a Hat*
Richard Thaler & Cass Sunstein's *Nudge: Improving Decisions About Health, Wealth and Happiness*
Amos Tversky's *Judgment under Uncertainty: Heuristics and Biases*
Philip Zimbardo's *The Lucifer Effect*

SCIENCE

Rachel Carson's *Silent Spring*
William Cronon's *Nature's Metropolis: Chicago And The Great West*
Alfred W. Crosby's *The Columbian Exchange*
Charles Darwin's *On the Origin of Species*
Richard Dawkin's *The Selfish Gene*
Thomas Kuhn's *The Structure of Scientific Revolutions*
Geoffrey Parker's *Global Crisis: War, Climate Change and Catastrophe in the Seventeenth Century*
Mathis Wackernagel & William Rees's *Our Ecological Footprint*

SOCIOLOGY

Michelle Alexander's *The New Jim Crow: Mass Incarceration in the Age of Colorblindness*
Gordon Allport's *The Nature of Prejudice*
Albert Bandura's *Aggression: A Social Learning Analysis*
Hanna Batatu's *The Old Social Classes And The Revolutionary Movements Of Iraq*
Ha-Joon Chang's *Kicking Away the Ladder*
W. E. B. Du Bois's *The Souls of Black Folk*
Émile Durkheim's *On Suicide*
Frantz Fanon's *Black Skin, White Masks*
Frantz Fanon's *The Wretched of the Earth*
Eric Foner's *Reconstruction: America's Unfinished Revolution, 1863-1877*
Eugene Genovese's *Roll, Jordan, Roll: The World the Slaves Made*
Jack Goldstone's *Revolution and Rebellion in the Early Modern World*
Antonio Gramsci's *The Prison Notebooks*
Richard Herrnstein & Charles A Murray's *The Bell Curve: Intelligence and Class Structure in American Life*
Eric Hoffer's *The True Believer: Thoughts on the Nature of Mass Movements*
Jane Jacobs's *The Death and Life of Great American Cities*
Robert Lucas's *Why Doesn't Capital Flow from Rich to Poor Countries?*
Jay Macleod's *Ain't No Makin' It: Aspirations and Attainment in a Low Income Neighborhood*
Elaine May's *Homeward Bound: American Families in the Cold War Era*
Douglas McGregor's *The Human Side of Enterprise*
C. Wright Mills's *The Sociological Imagination*

Thomas Piketty's *Capital in the Twenty-First Century*
Robert D. Putman's *Bowling Alone*
David Riesman's *The Lonely Crowd: A Study of the Changing American Character*
Edward Said's *Orientalism*
Joan Wallach Scott's *Gender and the Politics of History*
Theda Skocpol's *States and Social Revolutions*
Max Weber's *The Protestant Ethic and the Spirit of Capitalism*

THEOLOGY

Augustine's *Confessions*
Benedict's *Rule of St Benedict*
Gustavo Gutiérrez's *A Theology of Liberation*
Carole Hillenbrand's *The Crusades: Islamic Perspectives*
David Hume's *Dialogues Concerning Natural Religion*
Immanuel Kant's *Religion within the Boundaries of Mere Reason*
Ernst Kantorowicz's *The King's Two Bodies: A Study in Medieval Political Theology*
Søren Kierkegaard's *The Sickness Unto Death*
C. S. Lewis's *The Abolition of Man*
Saba Mahmood's *The Politics of Piety: The Islamic Revival and the Feminist Subject*
Baruch Spinoza's *Ethics*
Keith Thomas's *Religion and the Decline of Magic*

COMING SOON

Chris Argyris's *The Individual and the Organisation*
Seyla Benhabib's *The Rights of Others*
Walter Benjamin's *The Work Of Art in the Age of Mechanical Reproduction*
John Berger's *Ways of Seeing*
Pierre Bourdieu's *Outline of a Theory of Practice*
Mary Douglas's *Purity and Danger*
Roland Dworkin's *Taking Rights Seriously*
James G. March's *Exploration and Exploitation in Organisational Learning*
Ikujiro Nonaka's *A Dynamic Theory of Organizational Knowledge Creation*
Griselda Pollock's *Vision and Difference*
Amartya Sen's *Inequality Re-Examined*
Susan Sontag's *On Photography*
Yasser Tabbaa's *The Transformation of Islamic Art*
Ludwig von Mises's *Theory of Money and Credit*

Printed in the United States
by Baker & Taylor Publisher Services